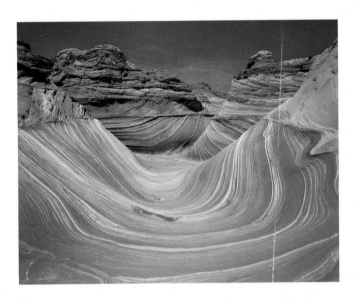

"If the desert is holy, it is because it is a forgotten place that allows us to remember the sacred. Perhaps that is why every pilgrimage to the desert is a pilgrimage to the self. There is no place to hide and so we are found."

— TERRY TEMPEST WILLIAMS

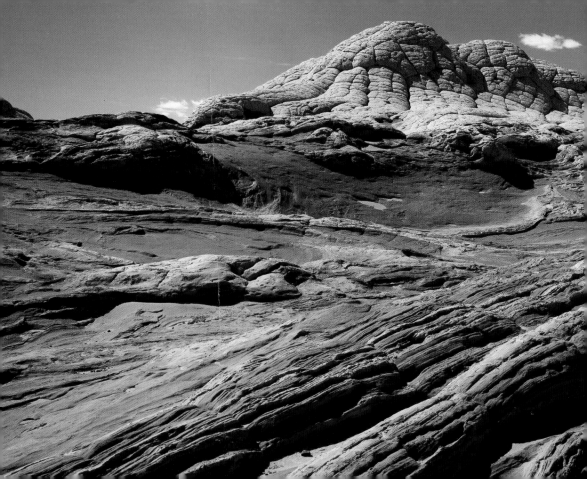

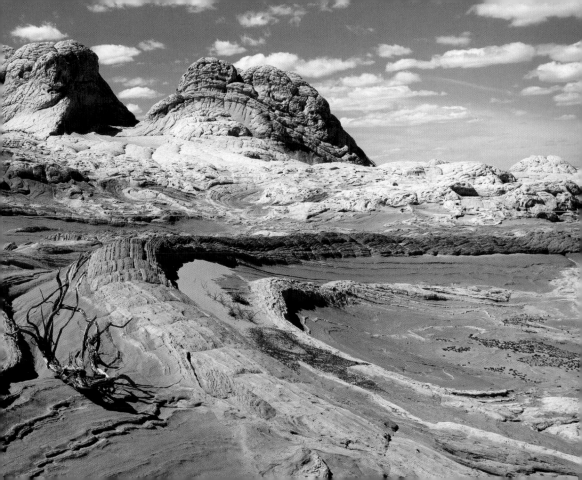

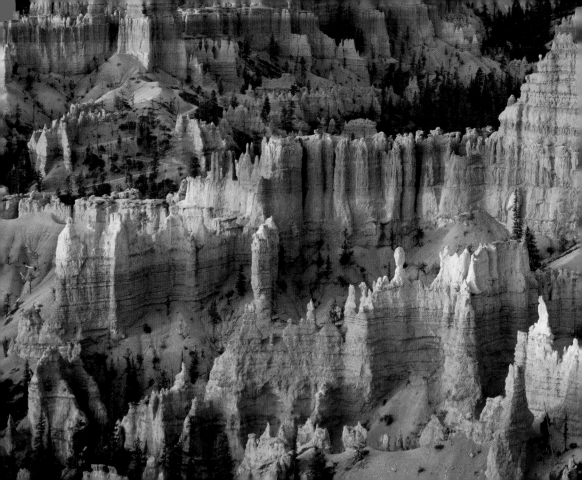

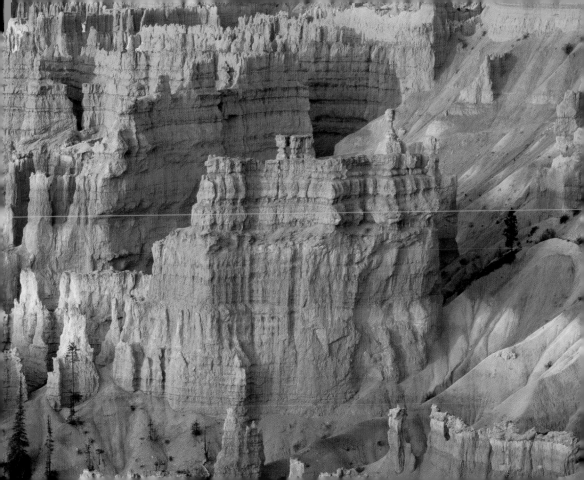

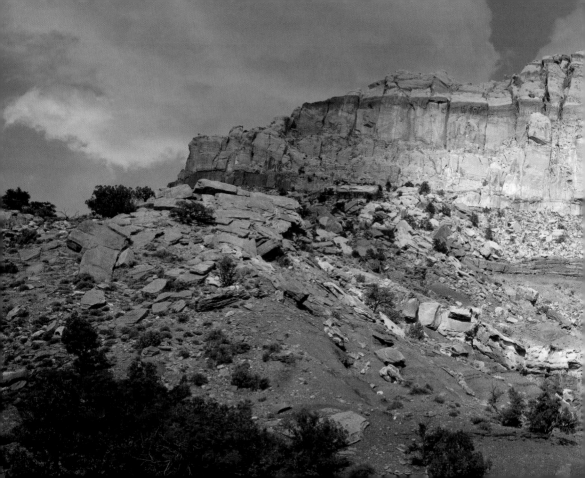

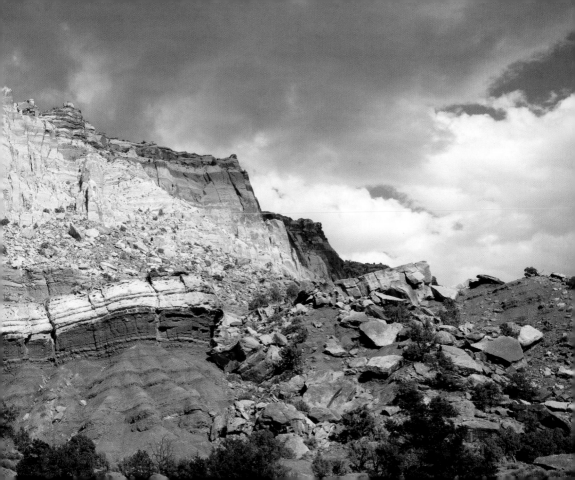

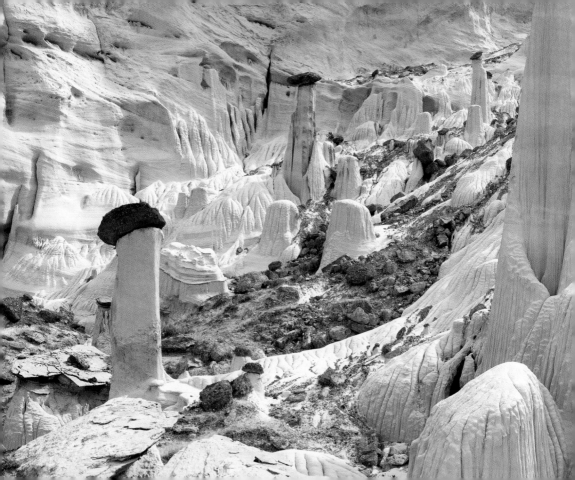

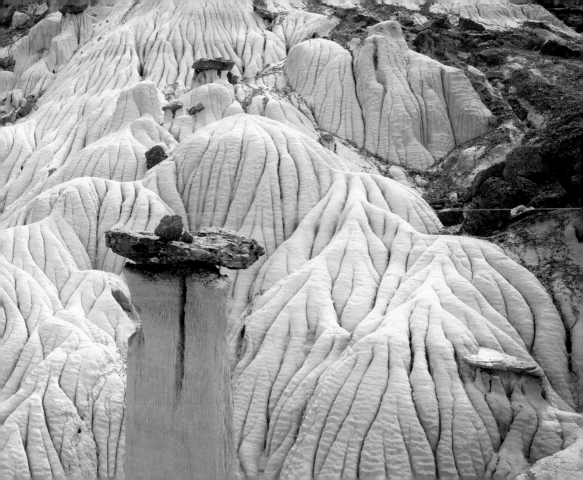

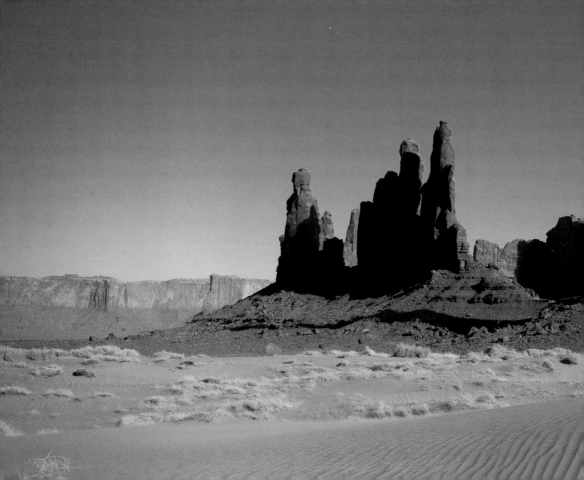

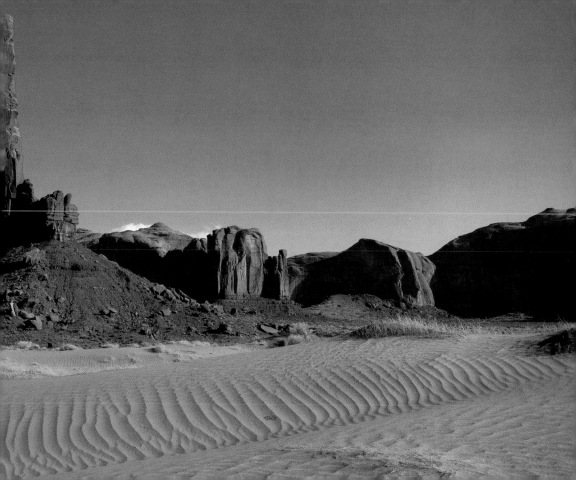

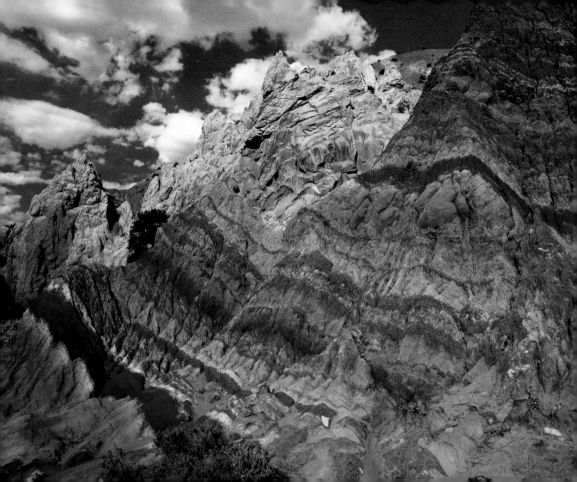

CANYON WILDERNESS
OF THE SOUTHWEST

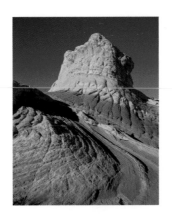

PHOTOGRAPHS BY JON ORTNER

INTRODUCTION BY GREER K. CHESHER

WELCOME BOOKS NEW YORK

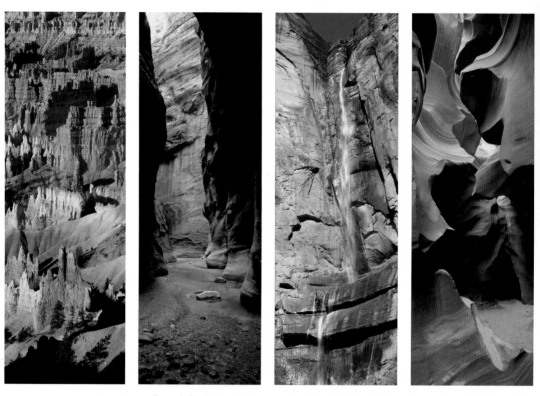

LEFT TO RIGHT: **Queen's Garden,** Bryce Canyon National Park, Utah. **Orderville Canyon,** Zion National Park, Utah. **Waterfall at Temple of Sinawava,** Zion National Park, Utah. **Antelope Canyon Navajo Tribal Park,** Arizona.

CONTENTS

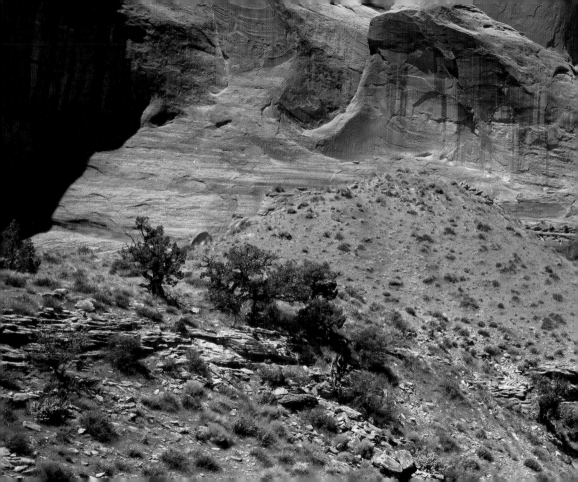

FOREWORD

Jon Ortner

I STAND TRANSFIXED IN THE TWILIGHT of dawn, in a state of reverie at the lip of Bryce Canyon, the chasm below enveloped in deep blue shadow. As the sun begins to peak over the eastern horizon, its first golden rays stream into a vast amphitheater of sandstone spires. A forest of towers and pinnacles begins to blaze in rich, radiant shades of pink, mauve, crimson, and yellow. A few weeks later, at Vermilion Cliffs Wilderness, once again the dreamlike landscapes of The Wave and White Pocket astound me. I am profoundly changed by the unimaginable beauty of nature.

Many explorers and artists have marveled at these wonders, and there is a rich body of literature describing the sublime colors and surreal shapes found in the desert Southwest. John Wesley Powell, great explorer of the Grand Canyon, wrote, "Beside the elements of form, there are the elements of color, for here the colors of the heavens are rivaled by the colors of the rocks. The rainbow is not more replete with hues." Ellen Meloy wrote in her book *Raven's Exile*, "This place, and no other, is my desired land, where color and light, nutrients as essential as food, live in sublime balance, a tranquil ecstasy."

Light and color have become my nutrients as well, and in an attempt to possess them and to somehow gain the deepest understanding of the desert, I make photographs. I have tried

INSIDE GATEFOLD: **Rainbow Bridge,** Rainbow Bridge National Monument, Utah.

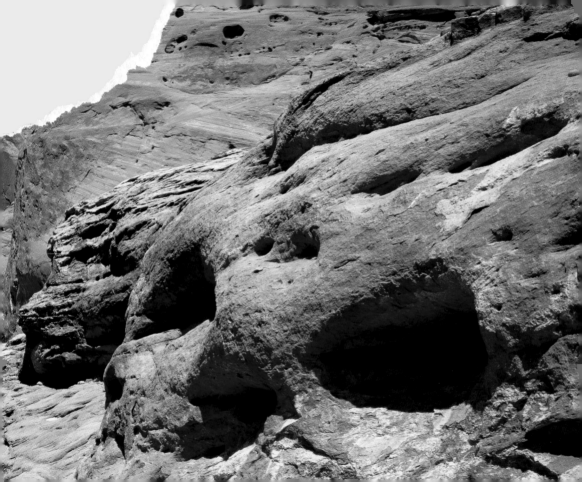

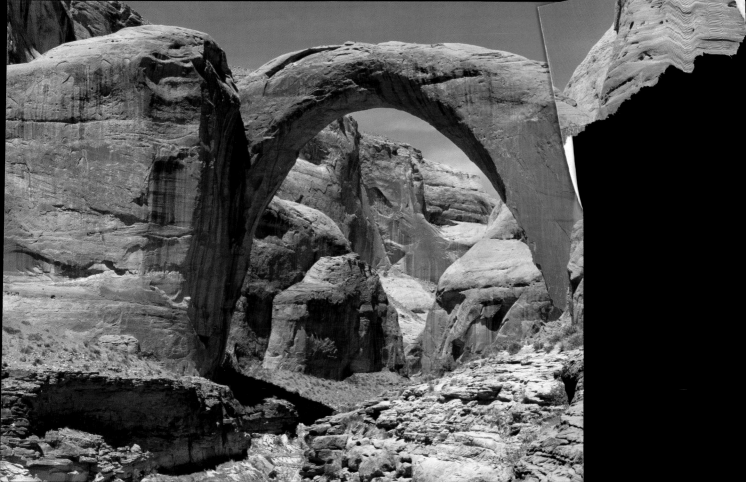

to capture on film those exquisite moments, tiny fractions of the ever-changing light and the infinite horizon upon which it plays. It is no less than the suspension of time. My reason for being there has evolved into a meditation upon that fleeting reflection of the divine. The more I photograph in the desert, the more I have been inspired and compelled to seek out not only that special quality of light, but the myriad secret places, the hidden slot canyons, the ochre dunes just over the next rise. Slowly, I am discovering a hallowed land of unparalleled grandeur.

As miles of trails pass under my feet, I begin to understand more about the geologic process that has created what I observe. Each layer, each sharply defined line in the sedimentary rock, represents the passage of incalculable eons. By seeing below the surface, I look down into the history of the creation of our planet. The layers of rock take me deeper into a past and into another reality that was here, millions of years ago.

How can a place characterized by emptine be important, full of mystery and meaning to many? It is in part because this vast and auste land still offers the rare opportunity to explo discover, and be fulfilled by the splendors of n ture. The desert is severe, intimidating, dange ous, yet it is able to engender love, passion, ar loyalty. For me the Colorado Plateau has become passion, even an obsession. Like my other passio the Himalaya, it is vast, complex, and filled wi exquisite and overpowering beauty, able to fulf a lifetime of desires for adventure and aesthet superlatives. In his 1933 book, *Beyond the Rainbo* Clyde Kluckhohn wrote, "There is no zest like th of exploration, no longing like that for the dese places, no call like that of the unknown."

I feel that call and have found what the *Hisat nom,* or the "ancestors," have always known; he one feels a palpable and mystical connection to th spirits that inhabit this place. What is discovere in the desert, in the worship of the desert, ring

th clarity, intelligence, and truth. We now have
ast chance to save what will be in the future the
ost coveted treasures of all: a breath of clean air,
ip of pure water, the silence and solitude that al-
ws one to hear the rush of the wind across the un-
oiled landscape.

Besides its scientific and scenic significance,
is extra-ordinary wilderness is America's most
ecious spiritual resource. It is a priceless gift
at, once destroyed, can never be created again.
preserving it, we recognize and honor the sanc-
y of the earth itself. Through the photographs in
is book I not only convey my profound love and
neration for this place, but also hope to capture
d preserve those moments of bliss, that however
eting, reveal the soul of Nature herself.

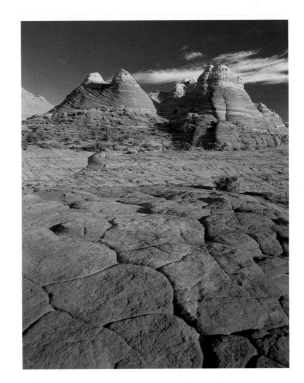

epees, Vermilion Cliffs Wilderness, Arizona.

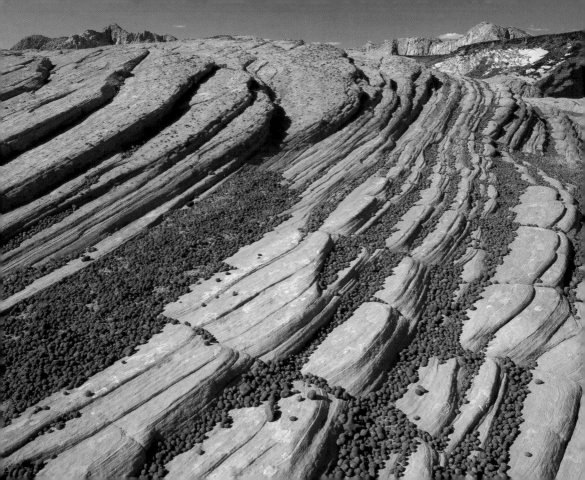

INTRODUCTION

Greer K. Chesher

THE RATTLESNAKE, COILED, FITS NICELY in the palm of my hand. Even though in the early morning coolness he's too lethargic to strike, I carefully restrain the back of his distinctly triangular head with thumb and forefinger. We are too remote to risk even this petite injection. The snake's tiny rattles are silent, but his tongue flicks, trying to ascertain through smell what detains him. My warmth rouses him, and I carefully set the young snake back on the canyon's red-sand floor, returning him to his cold-blooded torpor. I'm feeling a tad reptilian myself this morning in the narrow canyon's cool recesses, even though outside the day's heat blasts. Such is the canyon Southwest's remarkable contradiction—and perhaps appeal—cool respite hidden in desert heat; close embrace in the widest of open spaces; sanctity in the austere. This is a landscape big enough to celebrate opposites.

On this early summer day, a friend and I hike the Buckskin, a slender Paria Canyon tributary, under a clear sky, at least what we can see of it. I open my arms wide and, without straining, drag the fingertips of each hand along both canyon walls. Hundreds of feet overhead, a winding slot reveals a thin blue line of sky. This comforting azure is no real assurance. In the desert, heated updrafts swell into rain clouds and dump localized torrents on unsuspecting canyons. Overhead: clear sailing; up-canyon (and unseen): a deluge. Hurtling downhill and powered by constrictions, a flash flood's lead-

OPPOSITE: **Iron Concretions, Moqui Marbles,** Snow Canyon State Park, Utah.

23

ing edge can blast through narrow canyons without warning, rolling elephantine boulders, uprooting cottonwood trees, stripping bedrock raw.

This canyon reminds us of our tenuous passage: Every so often we see, 20 feet overhead, tree trunks wedged by previous floods. The desert's dangers are odd bedfellows: hypothermia and heat stroke, thirst and drowning. But what lends the canyons great danger also gives great beauty. Although water-worn canyons are often scoured bare, their sensuous curves and smooth skin echo water's flow. Danger and allure.

Six miles in, we reach camp—the only one in the Buckskin, a small ledge perched halfway up the canyon wall, above flood level. We unshoulder packs, set dinner on the camp stove, and scramble up the crack above our kitchen, topping out on the Paria Plateau, one of many uplifts riding the Colorado Plateau's broad back. The stony expanse, dotted with sage, piñon, and yucca, undulates toward the horizon. At our feet, a two-foot-wide crack runs like

a lightning bolt through stone, the only sign of t deep canyon below. We dare each other to jump but neither of us does, laughing at our timidity. Ea lier today we found a dead coyote lying as if sleepi on the canyon's soft dry sand, not a mark spoiling ruddy-gray fur, its perfect beauty. After long exam nation our only conjecture was the coyote had fall from the height where we now stand, too curio or oblivious to the unobtrusive crack's meaning notice its peril. Life and death.

Paria nests in the midst of the Colorado Platea most iconic landscapes. To the south, beyond t plateau's curve, lie Petrified Forest's painted san Grand Canyon's subterranean groove, and the st mysterious lands of Hopi and Navajo. North harbo Zion's redrock cliffs, Bryce and Cedar Breaks' terr cotta hoodoos, the flying buttresses of Canyonlan Arches, Capitol Reef. To the east, Grand Staircas Escalante National Monument stretches in ne roadless wonder. One could walk a lifetime he and never run out of awe. Paria itself lies within t

ureau of Land Management's Paria Canyon-Vermilion Cliffs Wilderness, part of Vermilion Cliffs ational Monument. In this place we walk surrounded by beauty. Surrounded by beauty, we walk.

Jon Ortner has also walked these places to our reat good fortune, and brought back images to gain embrace us in beauty. Radiant and subtle, on's landscapes work magic on us. Lingering over ach page-turning wonder my shoulders relax, I inhale deeply. I am once again in my proper place.

Long and lean, the Great Southwest is a place ifficult to capture on film. Jon's expertise catches nuances of light, cloudbursts of color, eons of space. he Southwest's frame-filling vistas stretch out nd breathe in Jon's distinctive panoramic format. We must turn our heads, use our bodies to experince these photographs just as we would in place. on's images of Grand Staircase-Escalante National Monument's narrow slots, Peek-A-Boo Canyon and pooky Gulch, are enticingly clear and creatively endered, especially given the great effort and perseverance required to lug camera gear to these remote niches.

Contemplating these photographs, one can almost feel sweat trickle between shoulder blades, the sun's bare-flesh intensity, water's improbable desert caress. These images also remind us of beauty's tender integrity, its life-threatening fragility. Jon's images call us to our own responsibility. They draw a circle in the sand within which wildness reigns. It will take everything in us to maintain that line. This landscape cannot encompass these opposites: beauty and ruin.

Tonight, back in our cliff-ledge camp, we eat dinner, replace the kitchen with sleeping bags, and joke about the startling consequences of rolling over in our sleep.

Tonight, and forever, we choose beauty.

Greer K. Chesher is author of *Zion Canyon: A Storied Land* and the award-winning *Heart of the Desert Wild: Grand Staircase-Escalante National Monument* as well as numerous other books and articles on the human/natural world.

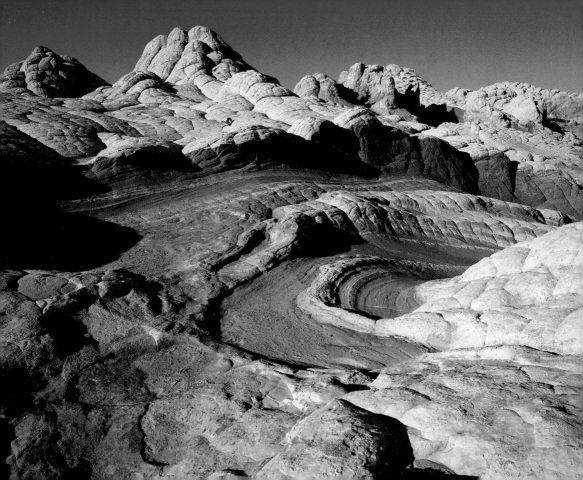

PARIA CANYON–VERMILION CLIFFS WILDERNESS & VERMILION CLIFFS NATIONAL MONUMENT

ARIZONA / UTAH

"The more one looks, the more (magically) there is to see. There can be no end to esthetic discovery in this land . . . The landscape here is one of idealized, archetypal forms: an intricate natural mosaic of surprise, expectation, anticipation, and excitement."

— WARD J. ROYLANCE

OPPOSITE: **White Pocket,** Vermilion Cliffs National Monument, Arizona.
FOLLOWING PAGES: **The Wave,** Paria Canyon-Vermilion Cliffs Wilderness, Arizona.

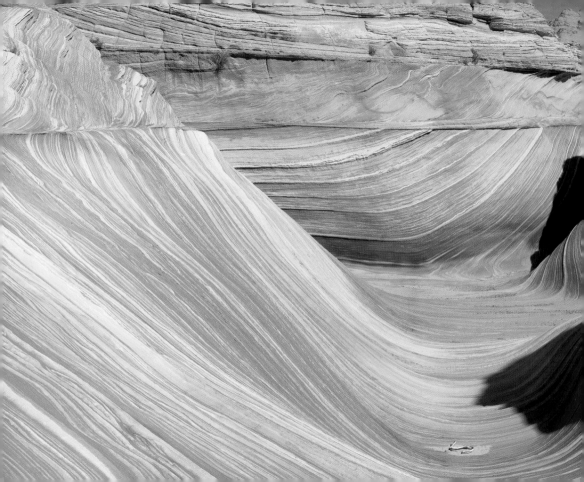

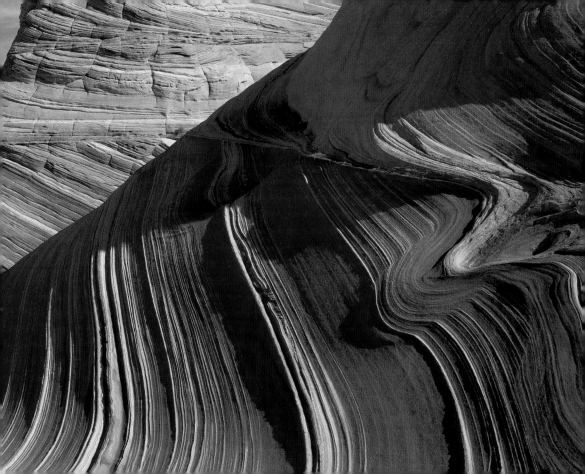

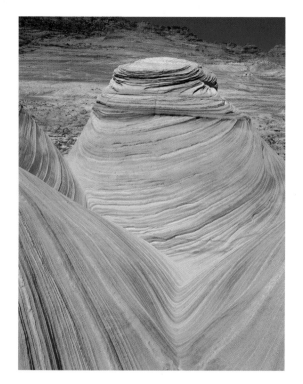

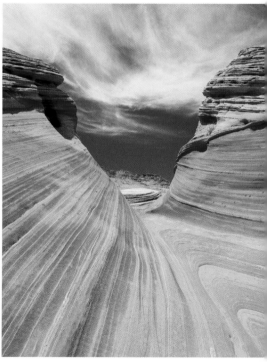

Coyote Buttes, Paria Canyon-Vermilion Cliffs Wilderness, Arizona

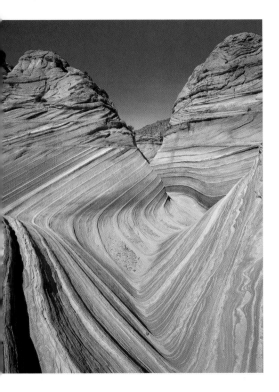

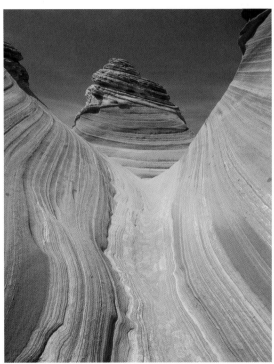

FT: **The Wave,** Paria Canyon-Vermilion Cliffs Wilderness, Arizona. RIGHT: **Coyote Buttes,** Paria Canyon-Vermilion Cliffs Wilderness, Arizona.

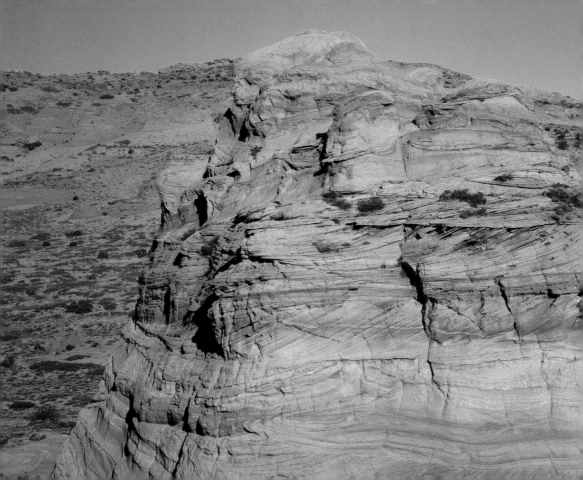

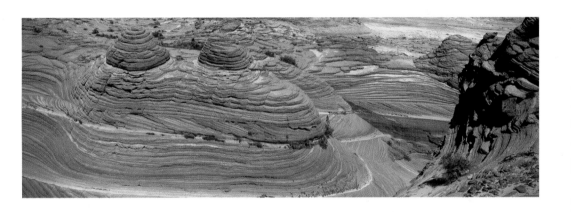

INSIDE GATEFOLD: **Cottonwood Cove,** Paria Canyon-Vermilion Cliffs Wilderness, Arizona.
ABOVE: **Sand Cove,** Paria Canyon-Vermilion Cliffs Wilderness, Arizona.
FOLLOWING PAGES: **The Wave,** Paria Canyon-Vermilion Cliffs Wilderness, Arizona.

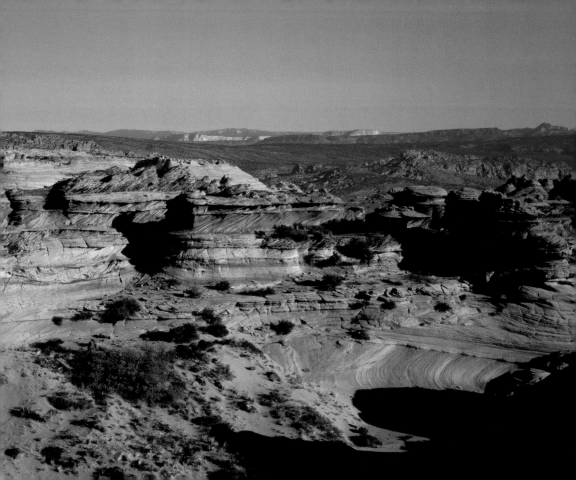

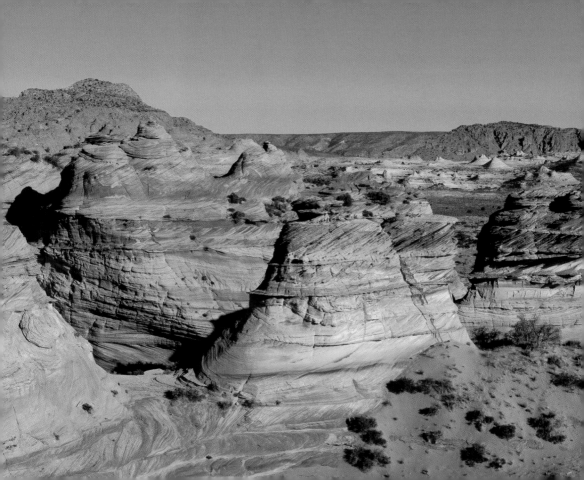

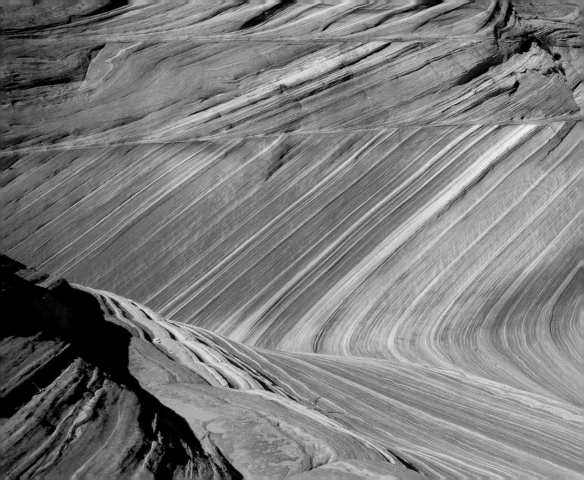

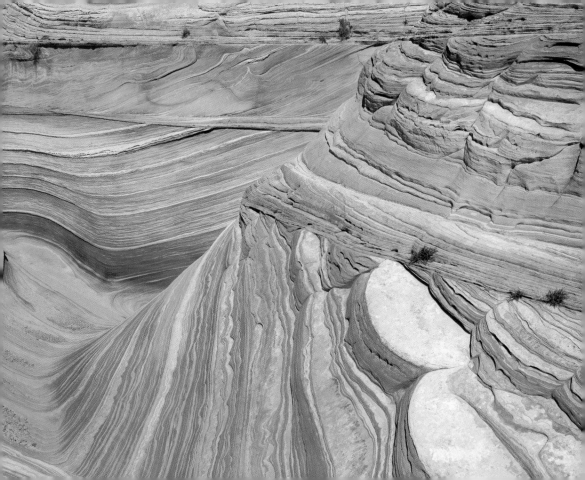

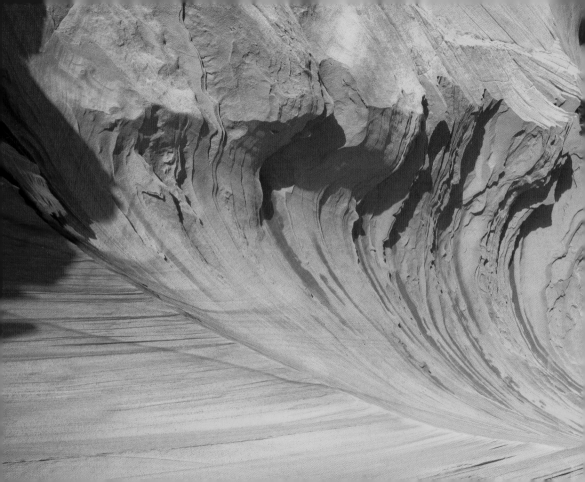

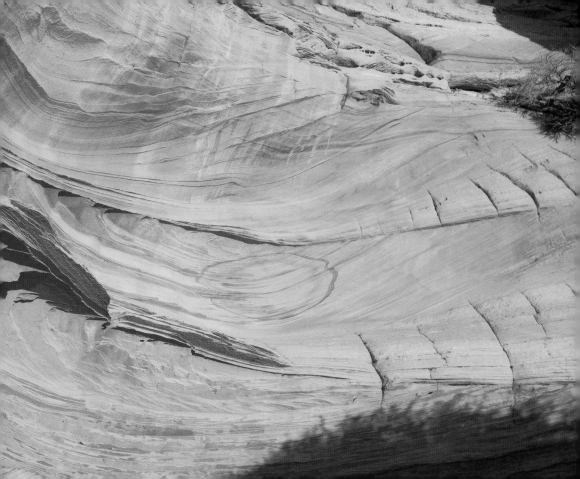

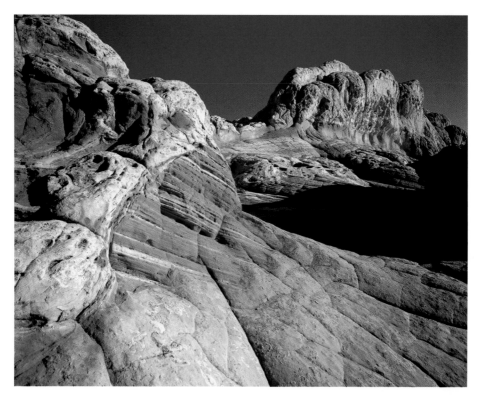

PREVIOUS PAGES: **Cottonwood Cove,** Paria Canyon-Vermilion Cliffs Wilderness, Arizona
ABOVE: **White Pocket,** Vermilion Cliffs National Monument, Arizona

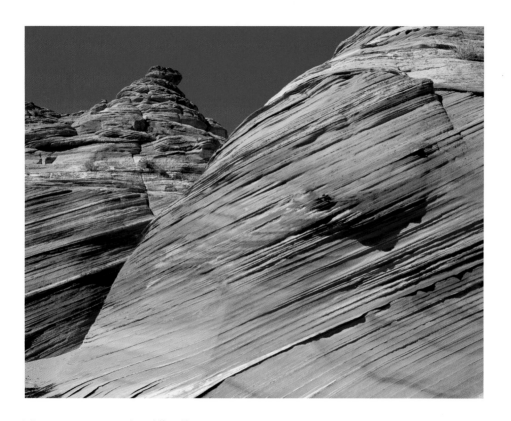

ttonwood Cove, Paria Canyon-Vermilion Cliffs Wilderness, Arizona.

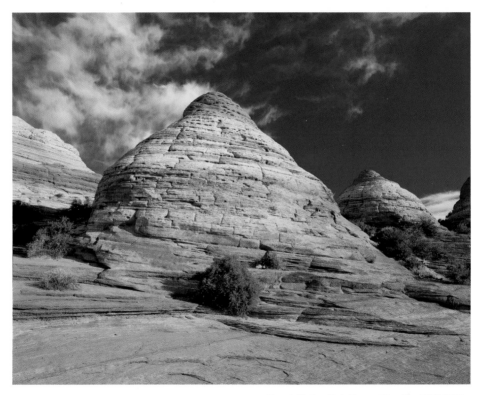

ABOVE: **Coyote Buttes,** Paria Canyon-Vermilion Cliffs Wilderness, Arizo

OPPOSITE: **The North Teepees,** Vermilion Cliffs National Monument, Arizo

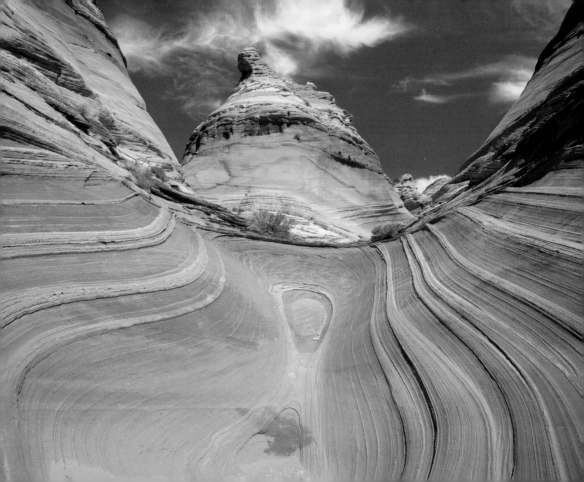

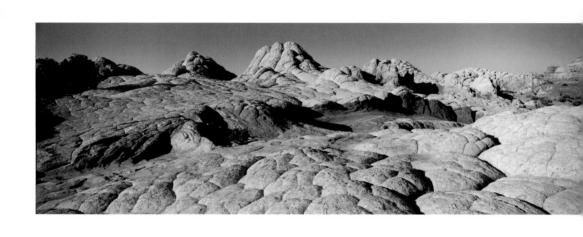

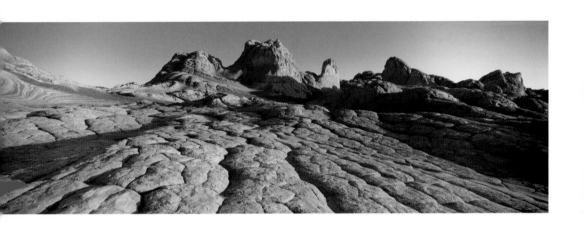

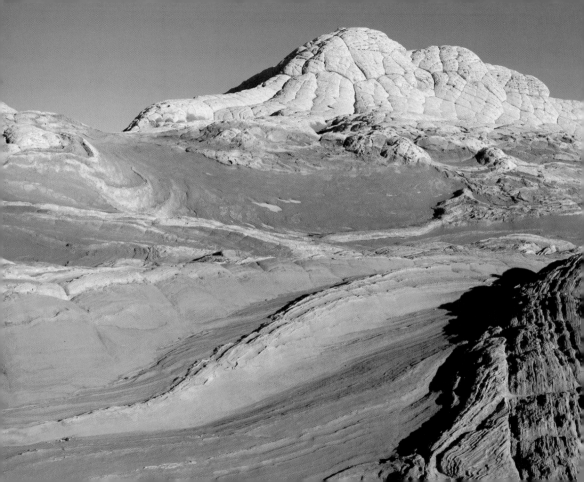

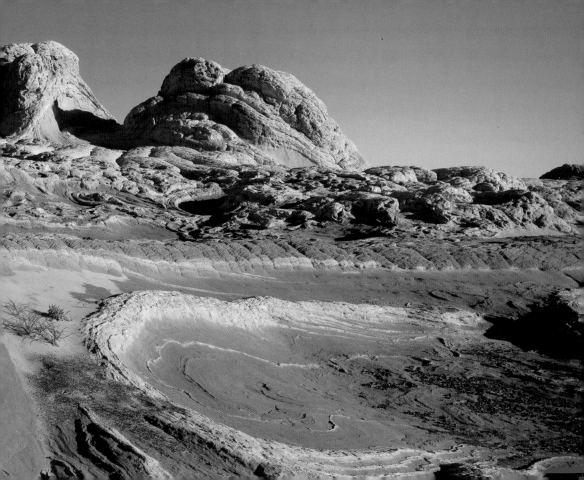

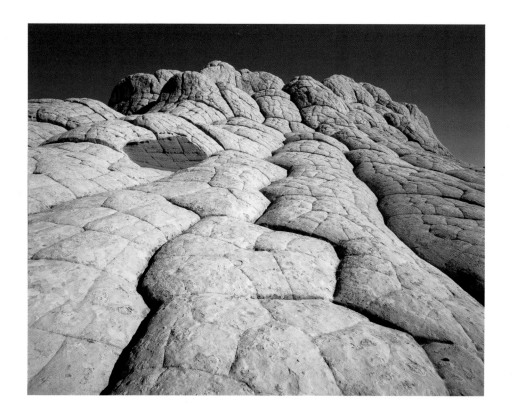

ABOVE AND OPPOSITE: **White Pocket,** Vermilion Cliffs National Monument, Arizo

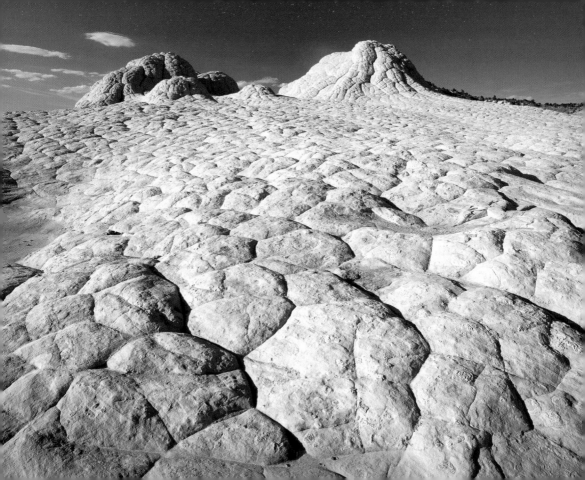

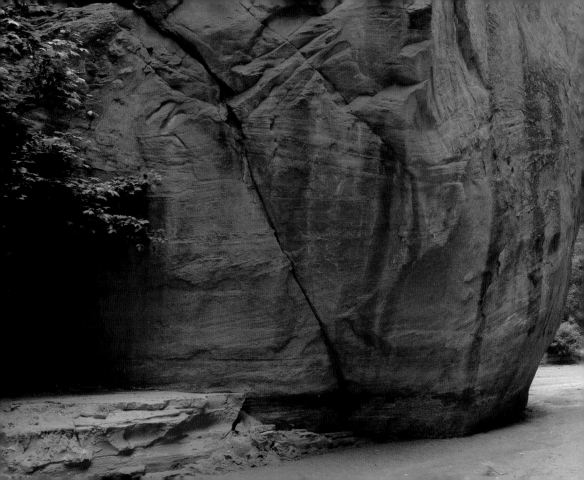

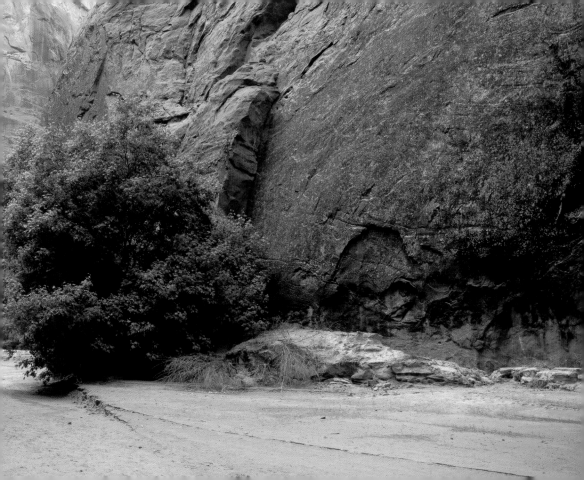

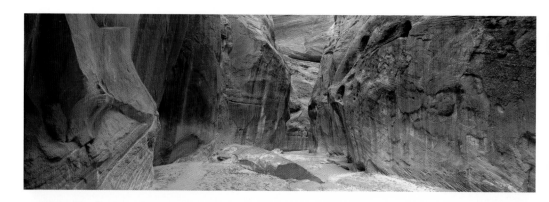

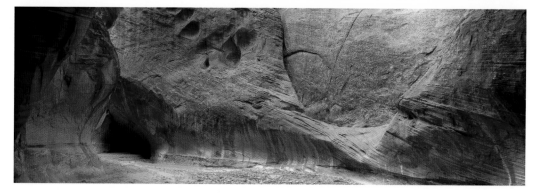

PREVIOUS PAGES AND ABOVE: **Paria River Narrows,** Paria Canyon-Vermilion Cliffs Wilderness, Ut

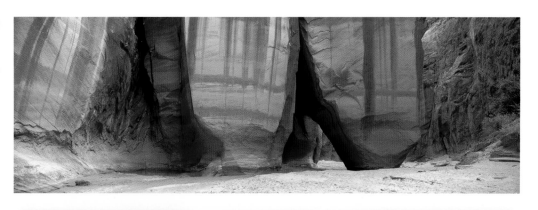

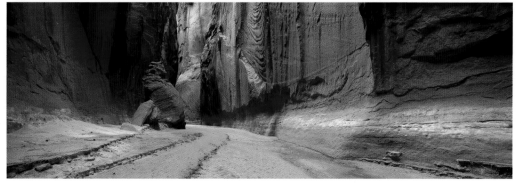

ABOVE AND FOLLOWING PAGES: **Paria River Narrows,** Paria Canyon-Vermilion Cliffs Wilderness, Utah.

53

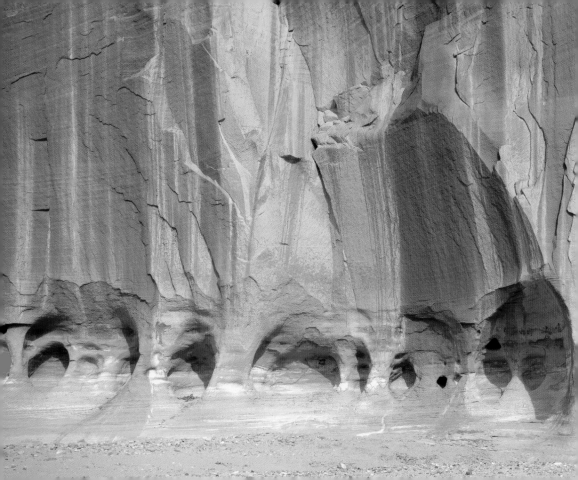

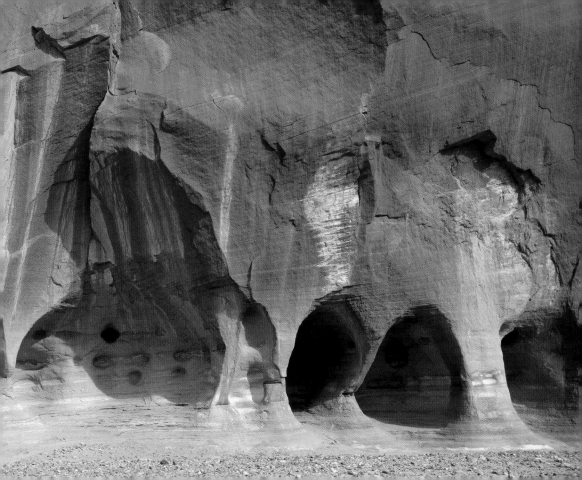

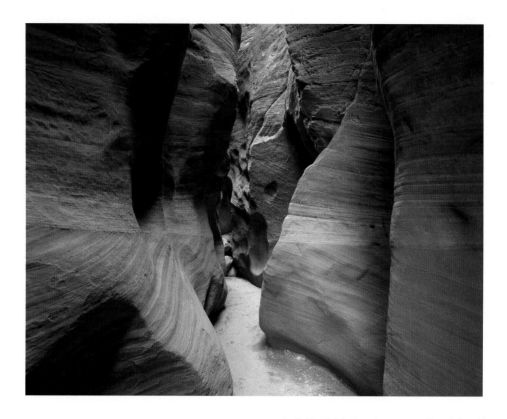

ABOVE AND OPPOSITE: **Buckskin Gulch,** Paria Canyon-Vermilion Cliffs Wilderness, U

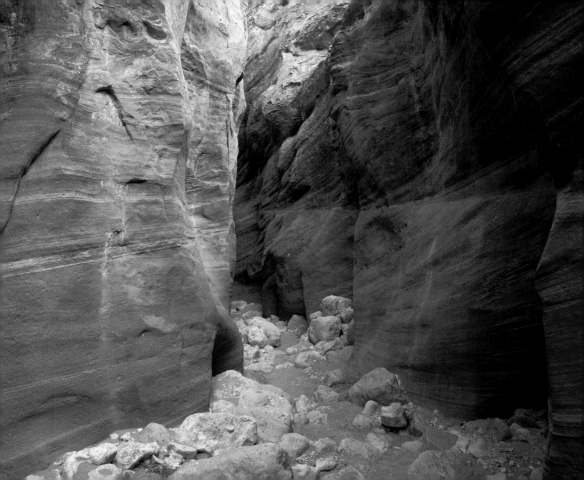

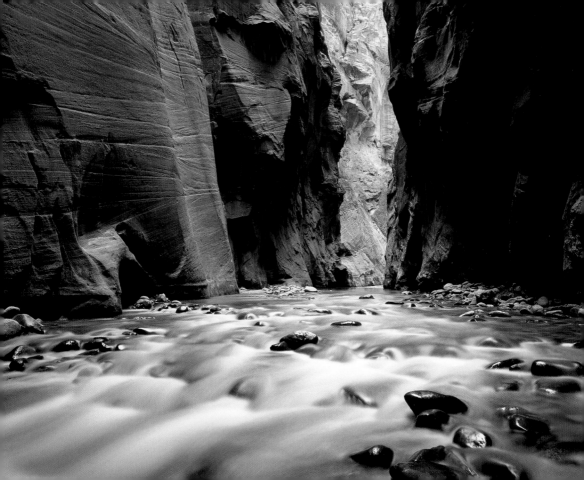

ZION NATIONAL PARK

"Heart of the whole and essence of the scene is the river, the flowing river with its thin fringe of green, the vital element in what would be otherwise a glamorous but moon-dead landscape. The living river and the living river alone gives coherence and significance and therefore beauty to the canyon world."

— EDWARD ABBEY

OPPOSITE AND FOLLOWING PAGES: **Virgin River Narrows,** Zion National Park, Utah.

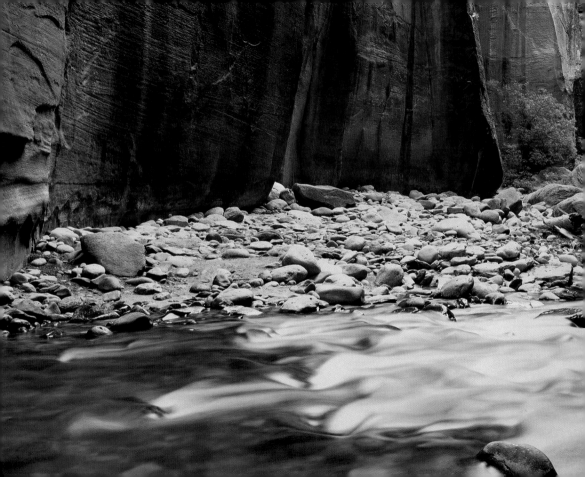

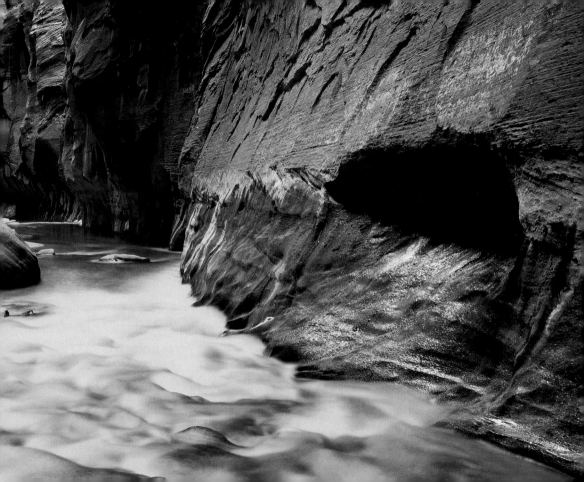

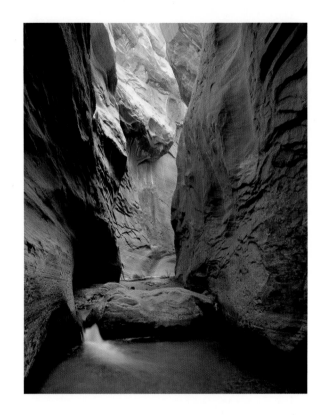

ABOVE: **Orderville Canyon,** Zion National Park, Utah. OPPOSITE: **Virgin River Narrows,** Zion National Park, U

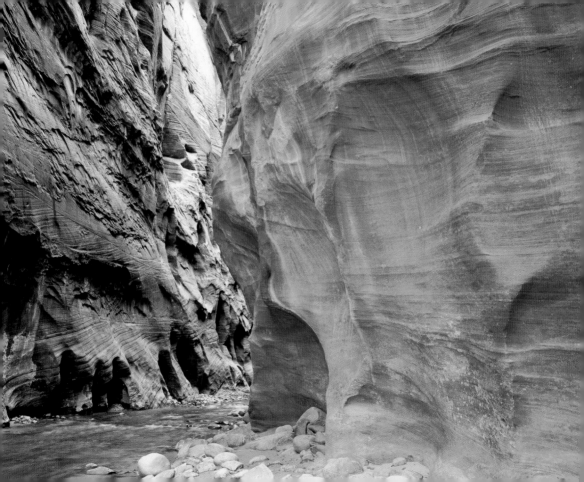

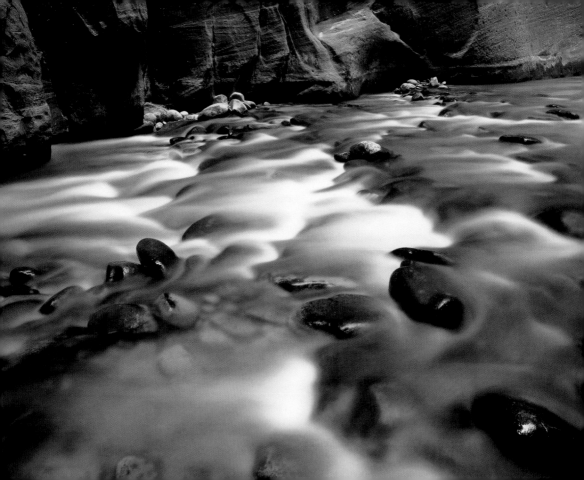

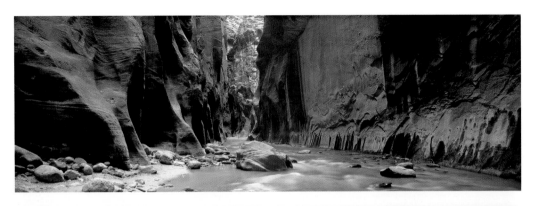

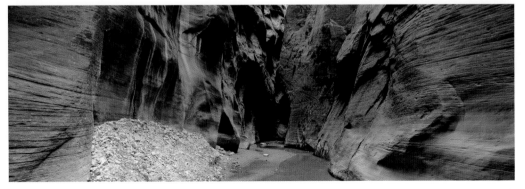

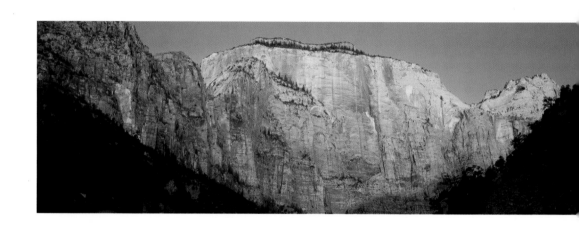

Western Temple & Towers of the Virgin, Zion National Park, Ut

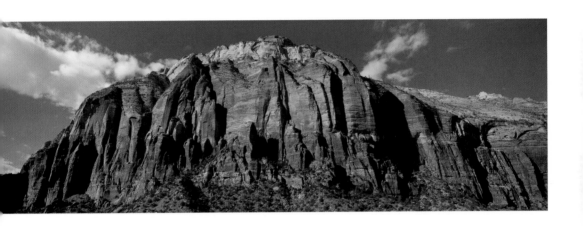

ABOVE: **The East Temple,** Zion National Park, Utah. FOLLOWING PAGES: **Waterfall at Temple of Sinawava,** Zion National Park, Utah. 67

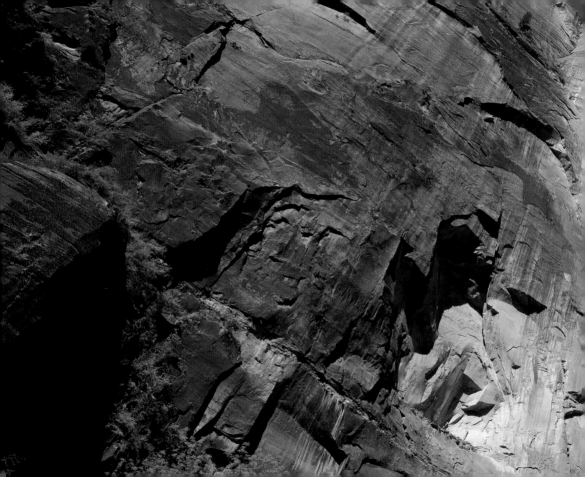

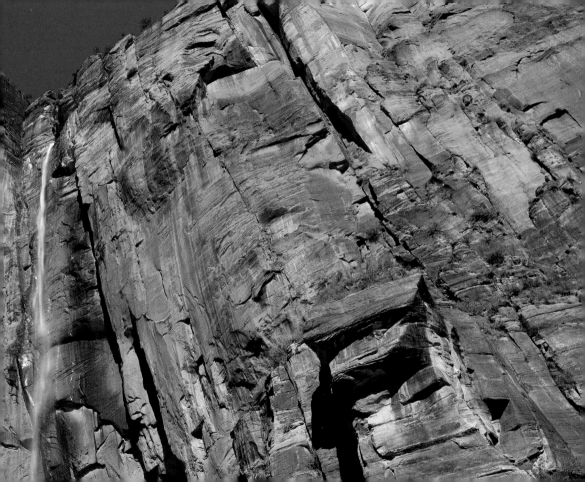

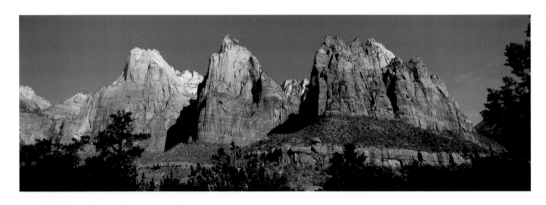

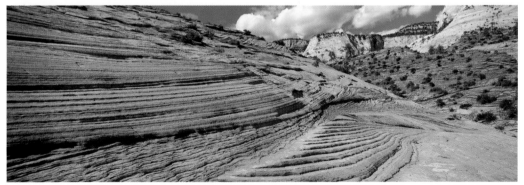

TOP: **Court of the Patriarchs,** Zion National Park, Utah. BOTTOM: **Clear Creek Canyon,** Zion National Park, Uta

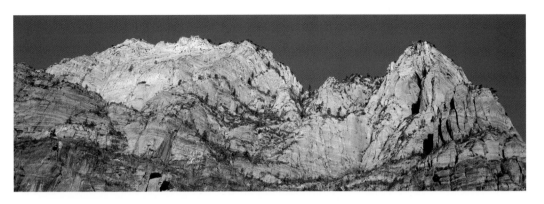

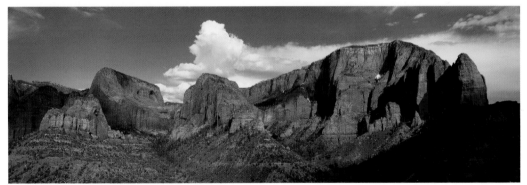

p: **Mount Moroni & Lady Mountain,** Zion National Park, Utah. BOTTOM: **Kolob Canyon,** Zion National Park, Utah.
LLOWING PAGES: **Clear Creek Canyon,** Zion National Park, Utah.

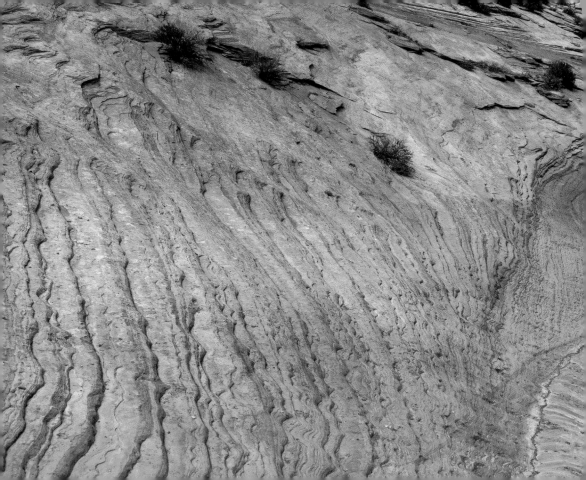

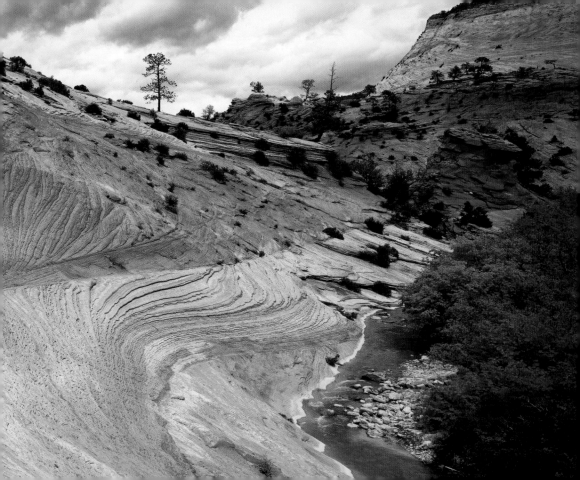

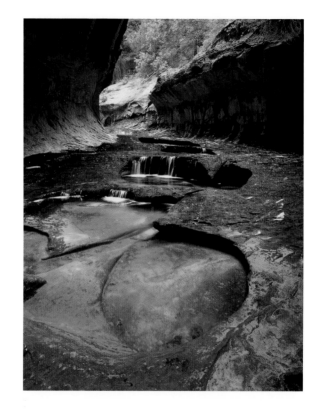

ABOVE: **The Subway,** Zion National Park, Utah. OPPOSITE: **Double Arch Alcove, Kolob Canyon,** Zion National Park, Uta

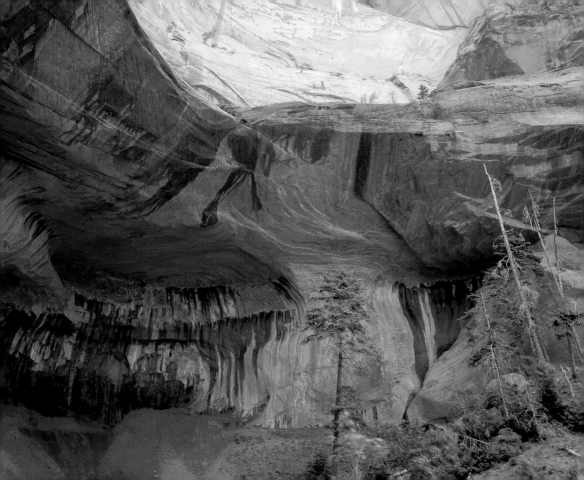

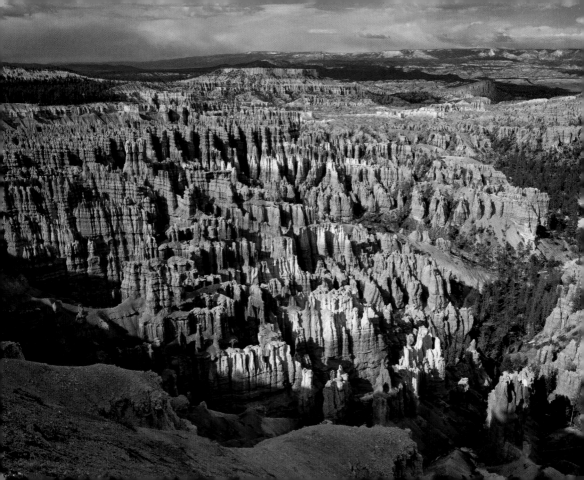

BRYCE CANYON NATIONAL PARK

UTAH

"The remnants of the land remain of impressive but fantastic wildness, mute witnesses of the powers of frenzied elements, wrecking the world. These were the powers that fashioned those monoliths that rise like lofty monuments from the southern plains . . . and they strewed over a region as large as an empire such bewildering spectacles of mighty shapes that Utah must always be the land sought by explorers of the strange and marvelous."

— HENRY L. A. CULMER

POSITE AND FOLLOWING PAGES: **Bryce Amphitheater from Bryce Point,** Bryce Canyon National Park, Utah.

77

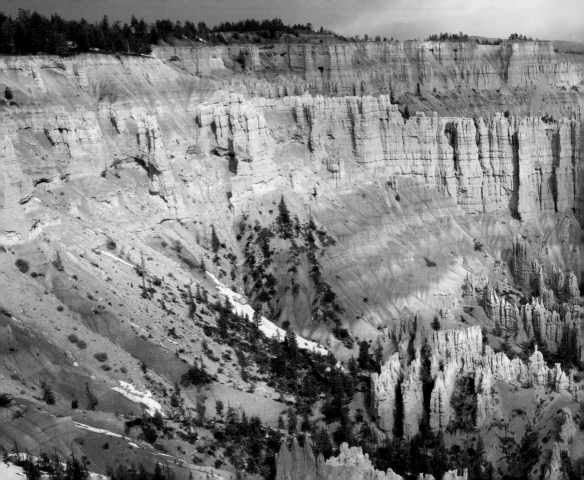

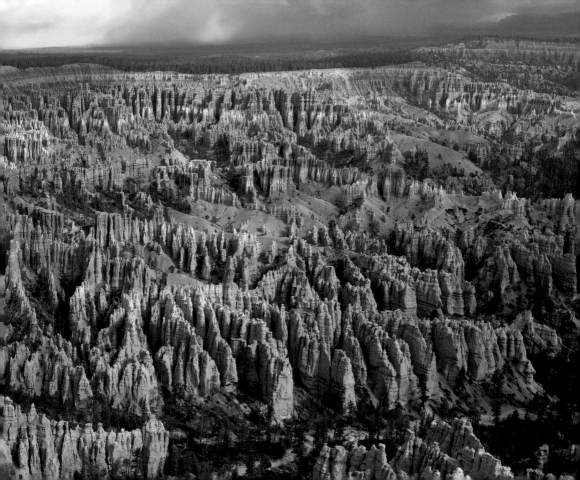

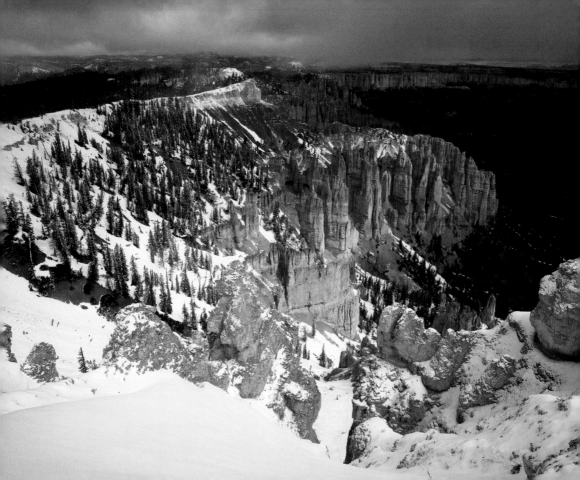

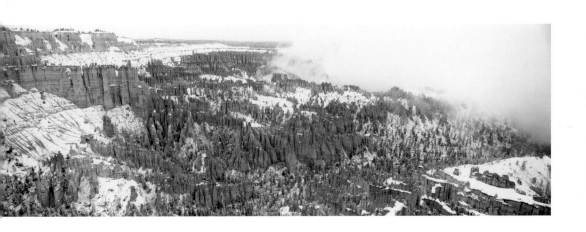

OPPOSITE: **Agua Canyon from Rainbow Point,** Bryce Canyon National Park, Utah.
ABOVE: **Bryce Amphitheater from Bryce Point,** Bryce Canyon National Park, Utah.

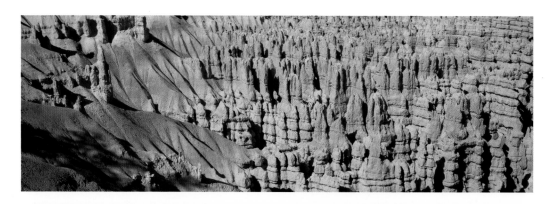

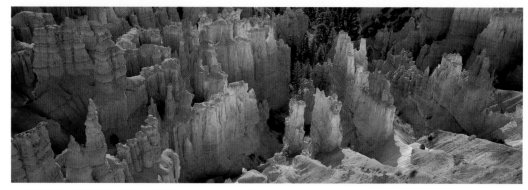

TOP: **Hoodoos, near Inspiration Point,** Bryce Canyon National Park, Uta
BOTTOM: **Hoodoos, near Sunset Point,** Bryce Canyon National Park, Uta

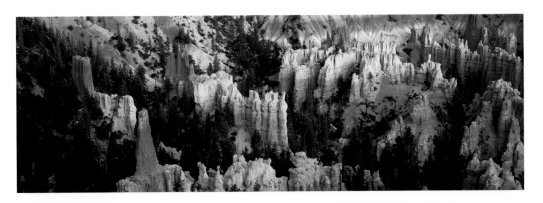

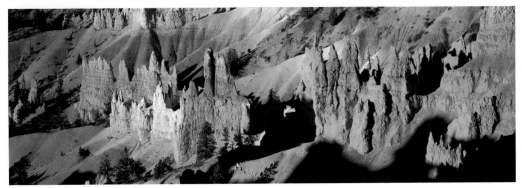

TOP: **Peek-A-Boo Loop Trail,** Bryce Canyon National Park, Utah.

BOTTOM: **Queen's Garden from Sunrise Point,** Bryce Canyon National Park, Utah.

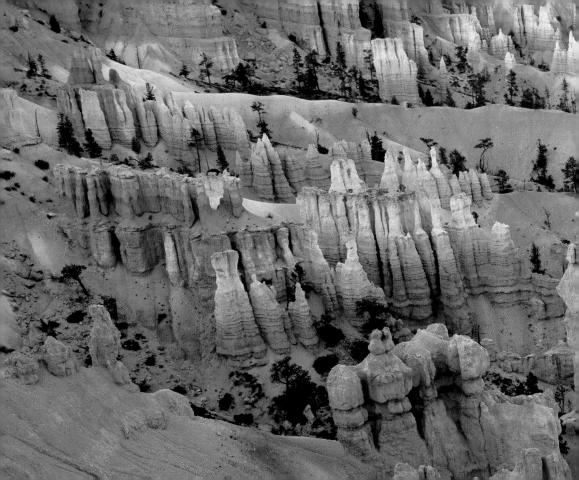

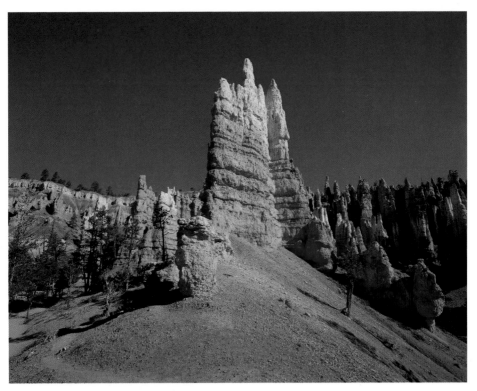

INSIDE GATEFOLD: **Bryce Amphitheater from Sunset Point,** Bryce Canyon National Park, Utah.
ABOVE: **Fairyland Canyon,** Bryce Canyon National Park, Utah.

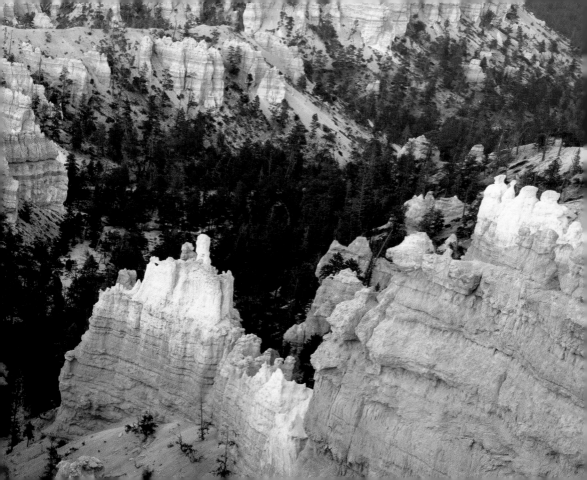

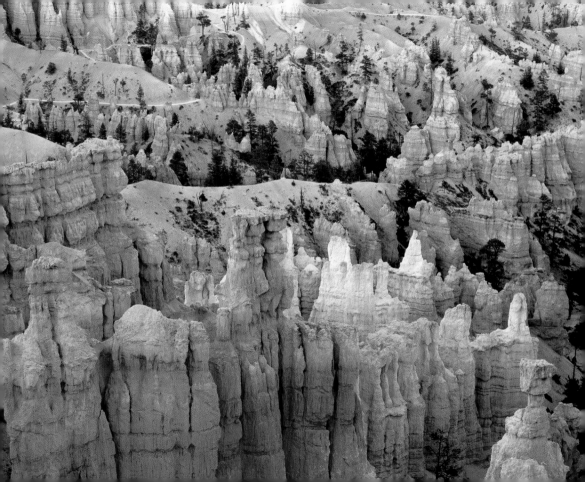

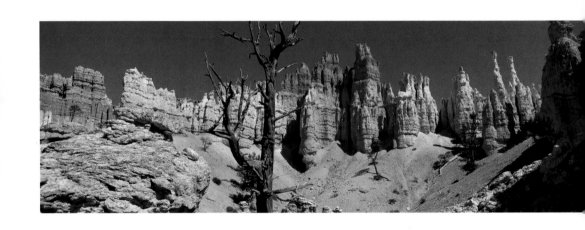

Peek-A-Boo Loop Trail, Bryce Canyon National Park, U

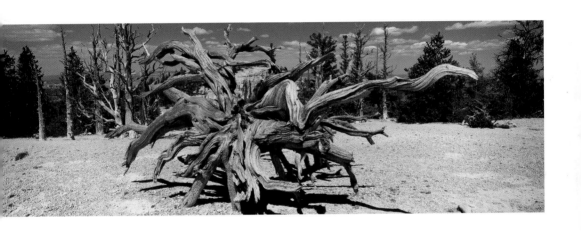

istlecone Pine, near Rainbow Point, Bryce Canyon National Park, Utah.

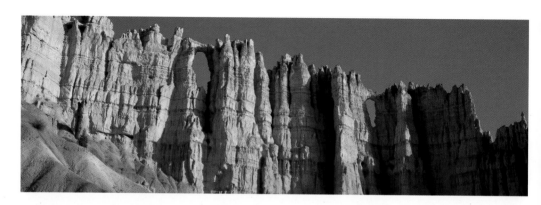

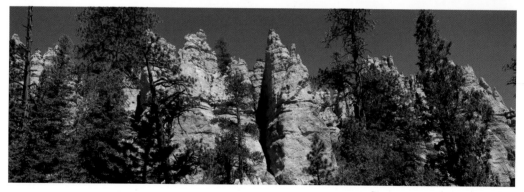

TOP: **Wall of Windows from Peek-A-Boo Loop Trail,** Bryce Canyon National Park, Ut.
BOTTOM: **Peek-A-Boo Loop Trail,** Bryce Canyon National Park, Utah. OPPOSITE: **Fairyland Canyon,** Bryce Canyon National Park, Ut.

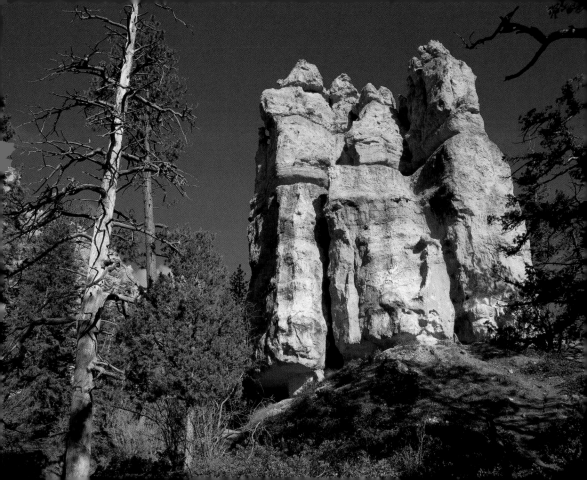

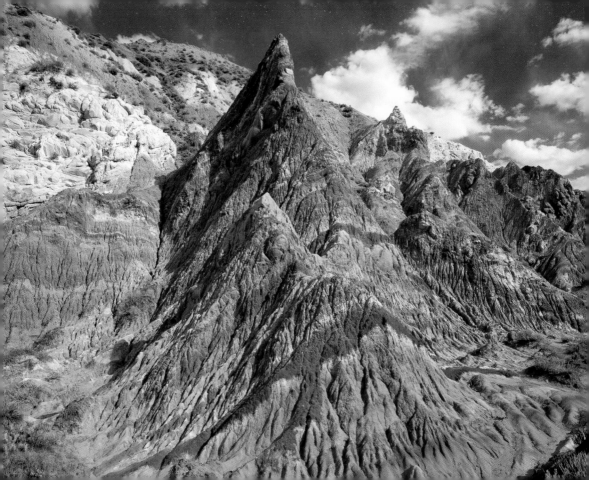

GRAND STAIRCASE–ESCALANTE NATIONAL MONUMENT

UTAH

"When we think of rock we usually think of stones, broken rock, buried under soil and plant life, but here all is exposed and naked, dominated by the monolithic formations of sandstone which stand above the surface of the ground and extend for miles, sometimes level, sometimes tilted or warped by pressure from below, carved by erosion and weathering into an intricate maze of glens, grottoes, fissures, passageways, and deep narrow canyons."

— EDWARD ABBEY

OPPOSITE: **The Cockscomb, Cottonwood Canyon,** Grand Staircase-Escalante National Monument, Utah.
FOLLOWING PAGES: **Lick Wash,** Grand Staircase-Escalante National Monument, Utah.

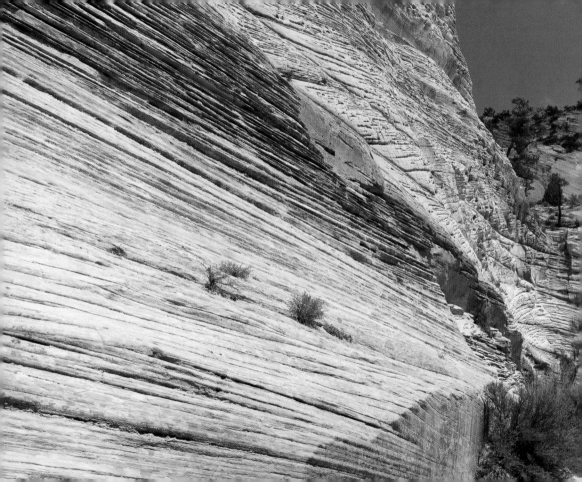

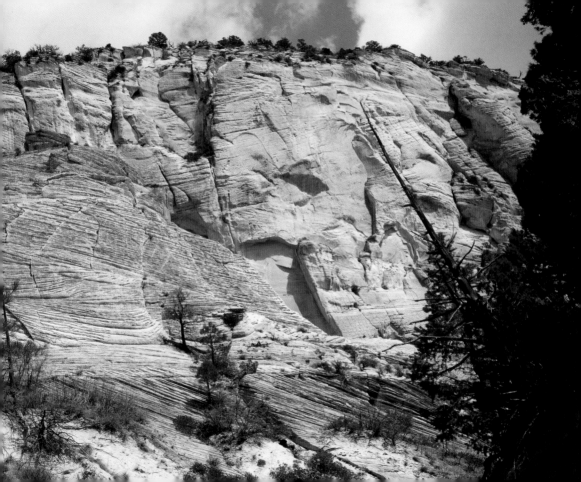

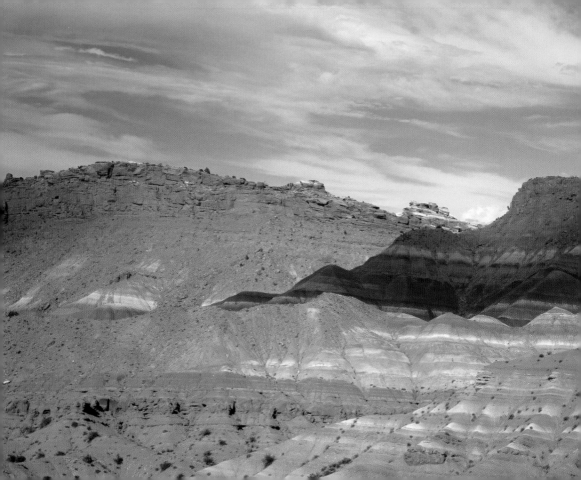

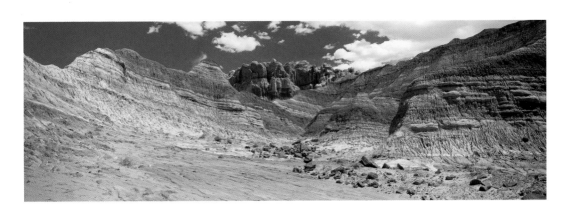

INSIDE GATEFOLD: **Paria Badlands,** Grand Staircase-Escalante National Monument, Utah.
ABOVE: **The Rimrocks,** Grand Staircase-Escalante National Monument, Utah.

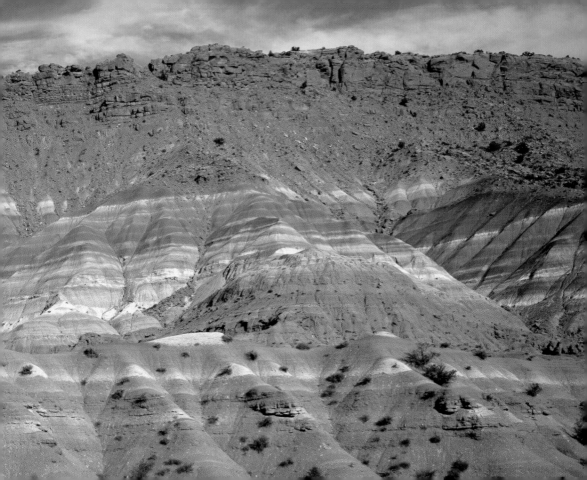

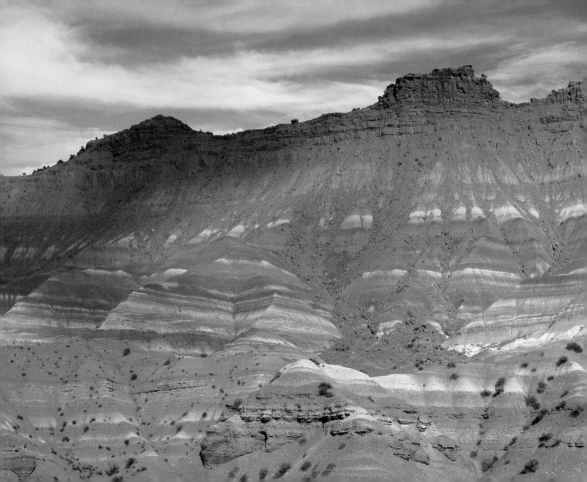

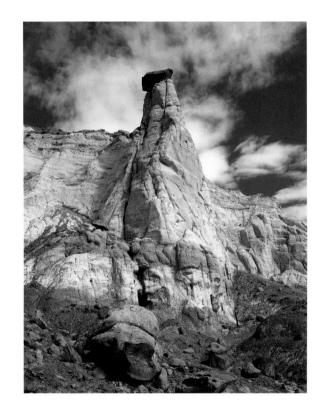

ABOVE AND OPPOSITE: **The Rimrocks,** Grand Staircase-Escalante National Monument, Utah

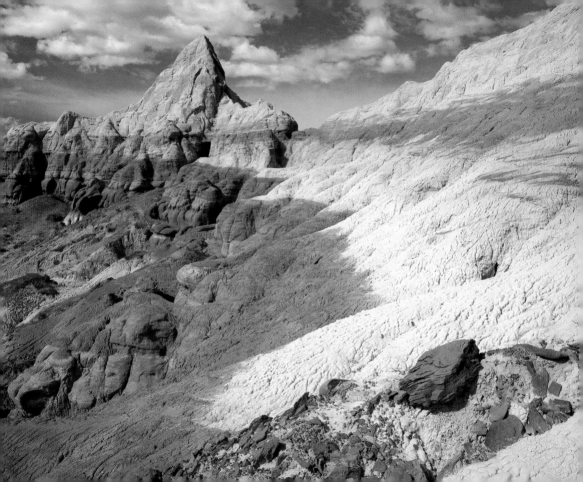

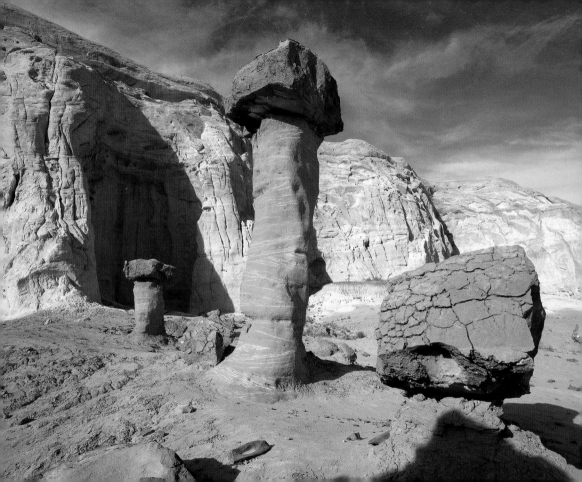

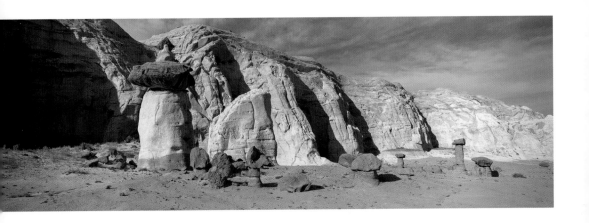

OPPOSITE AND ABOVE: **Toadstools, The Rimrocks,** Grand Staircase-Escalante National Monument, Utah.
FOLLOWING PAGES: **The Cockscomb, Cottonwood Canyon,** Grand Staircase-Escalante National Monument, Utah.

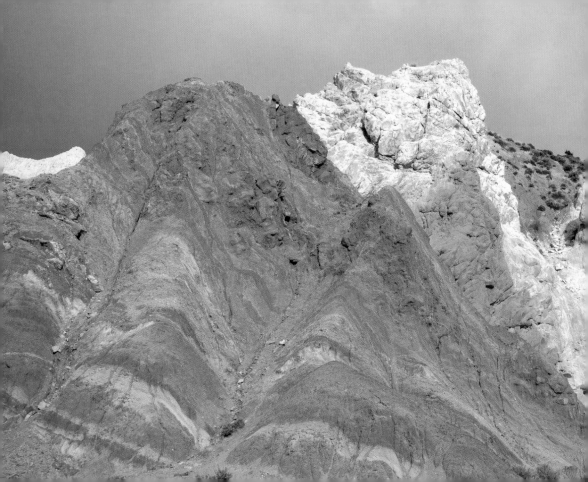

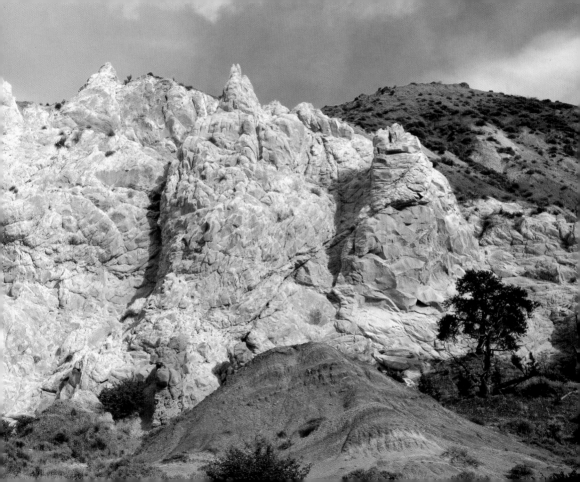

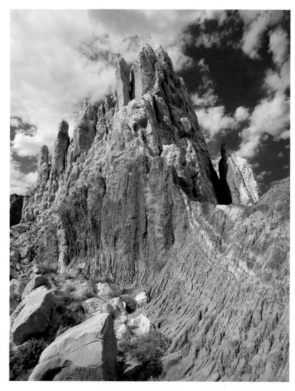

ABOVE: **The Cockscomb, Cottonwood Canyon,** Grand Staircase-Escalante National Monument, U

OPPOSITE: **Yellow Rock,** Grand Staircase-Escalante National Monument, U

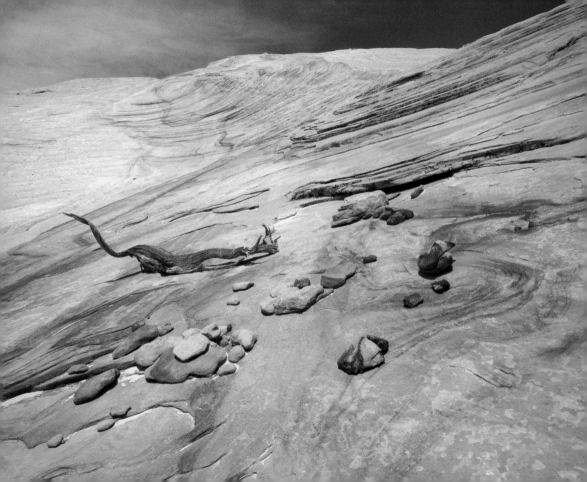

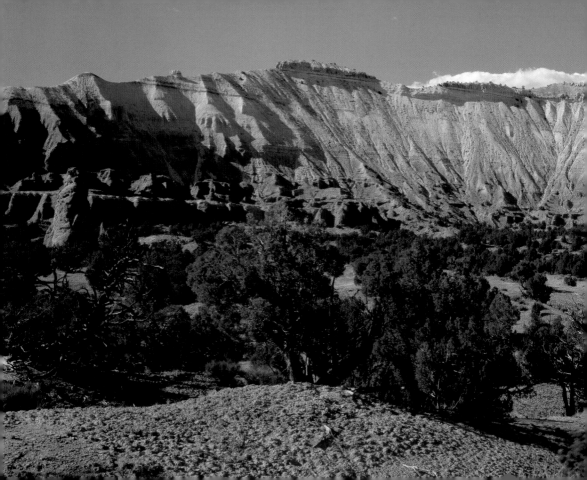

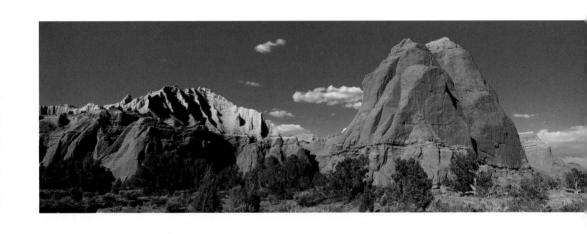

ABOVE: **Grand Parade Trail,** Kodachrome Basin State Park, Utah. OPPOSITE: **Balance Rock,** Glen Canyon National Recreation Area, U

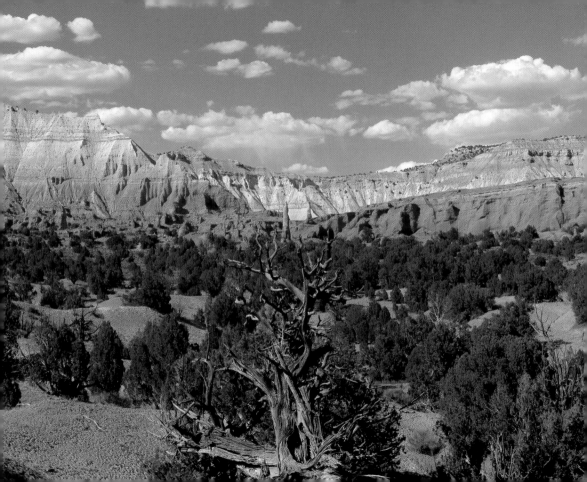

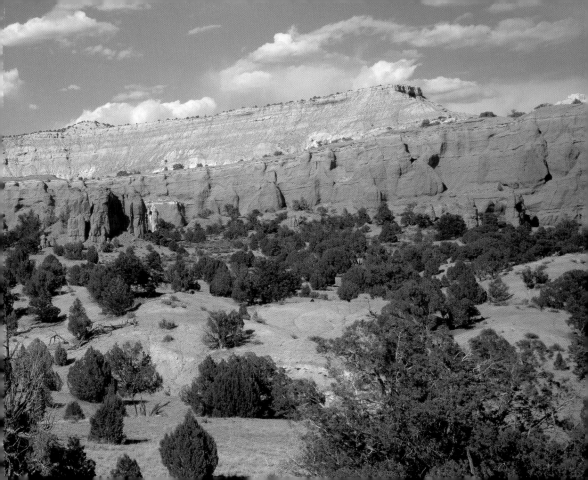

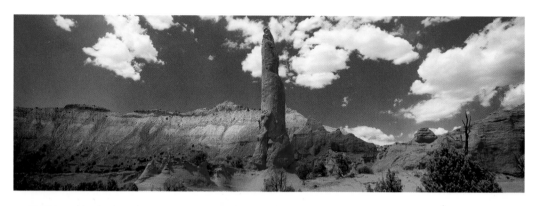

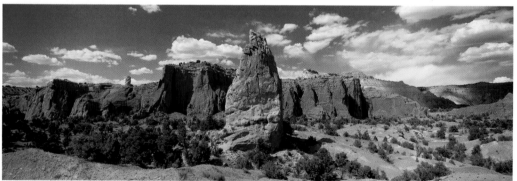

INSIDE GATEFOLD: **Panorama Trail,** Kodachrome Basin State Park, Utah. TOP: **Ballerina Spire,** Kodachrome Basin State Park, Utah.
BOTTOM: **Mammoth Geyser,** Kodachrome Basin State Park, Utah.

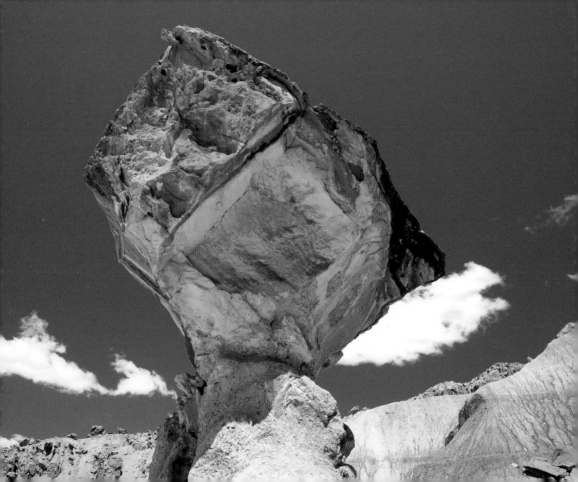

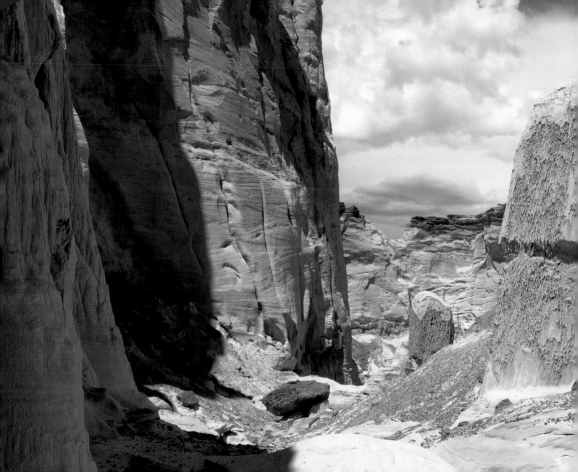

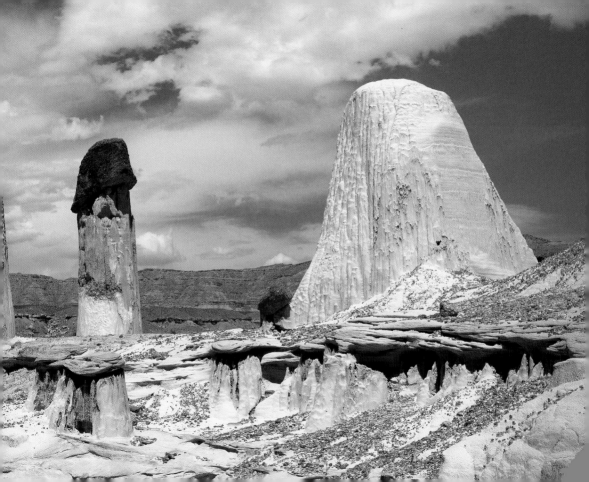

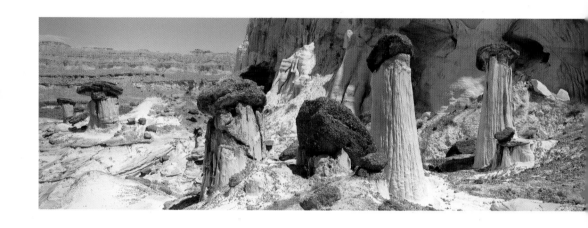

PREVIOUS AND THESE PAGES: **Hoodoos, Wahweap Creek,** Grand Staircase-Escalante National Monument, Uta

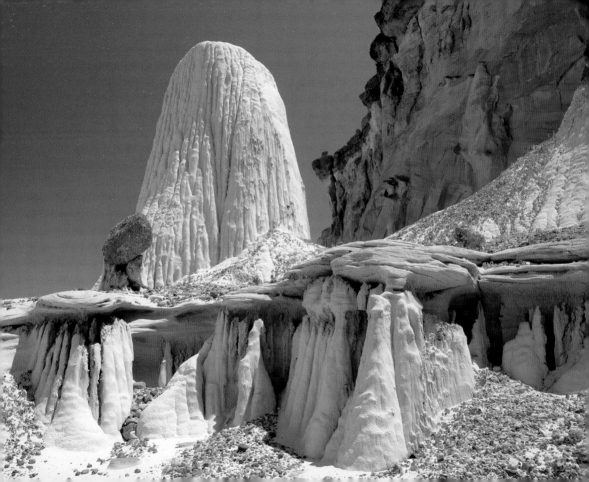

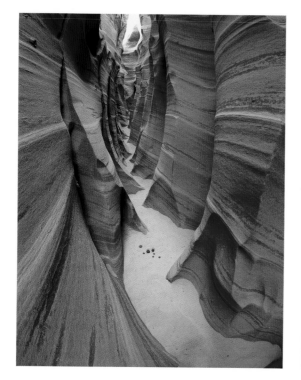

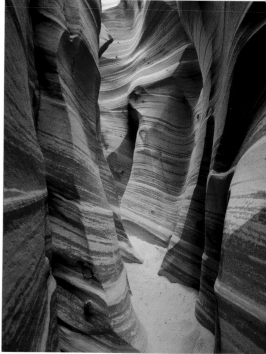

ABOVE AND OPPOSITE: **Zebra Canyon,** Grand Staircase-Escalante National Monument, Utah

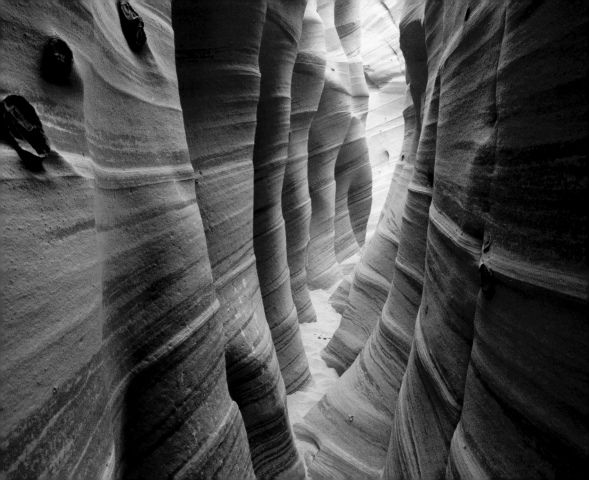

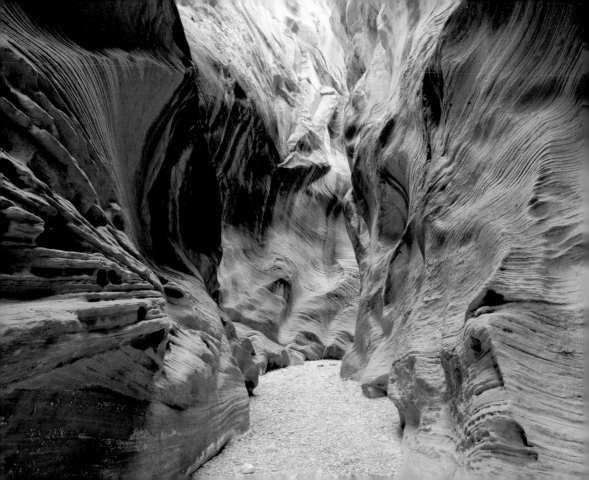

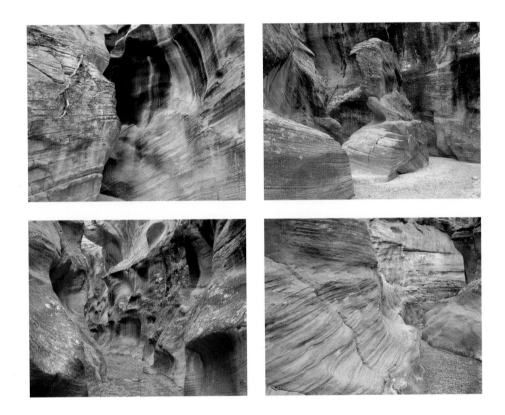

OPPOSITE AND ABOVE: **Willis Creek,** Grand Staircase-Escalante National Monument, Utah.

121

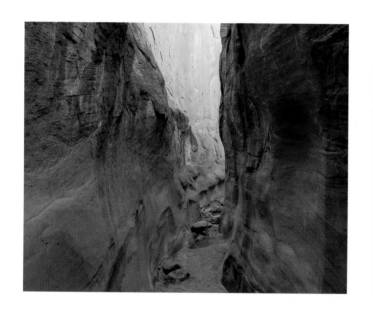

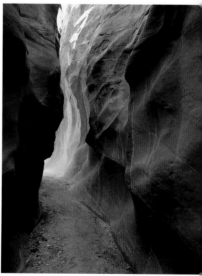

ABOVE: **Dry Fork of Coyote Gulch,** Grand Staircase-Escalante National Monument, Utah

OPPOSITE: **Spooky Gulch,** Grand Staircase-Escalante National Monument, Utah

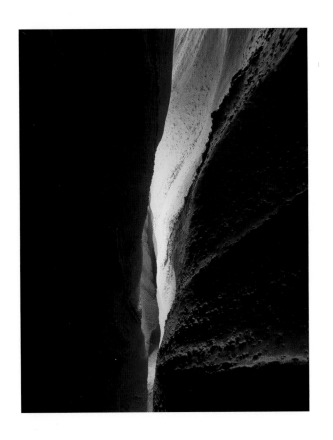

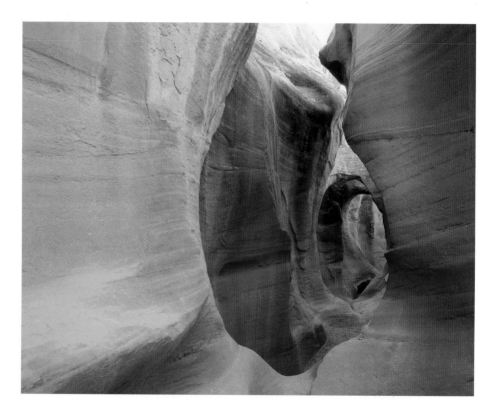

ABOVE AND OPPOSITE: **Peek-a-Boo Gulch,** Grand Staircase-Escalante National Monument, Uta

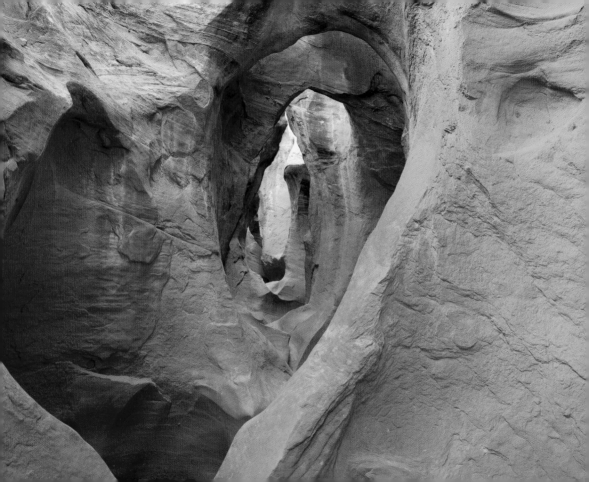

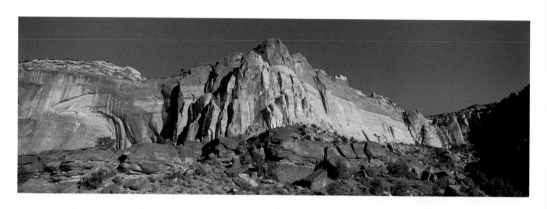

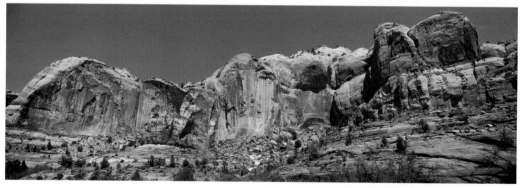

ABOVE: **Calf Creek Canyon,** Grand Staircase-Escalante National Monument, Utah

OPPOSITE: **Lower Calf Creek Falls,** Grand Staircase-Escalante National Monument, Utah

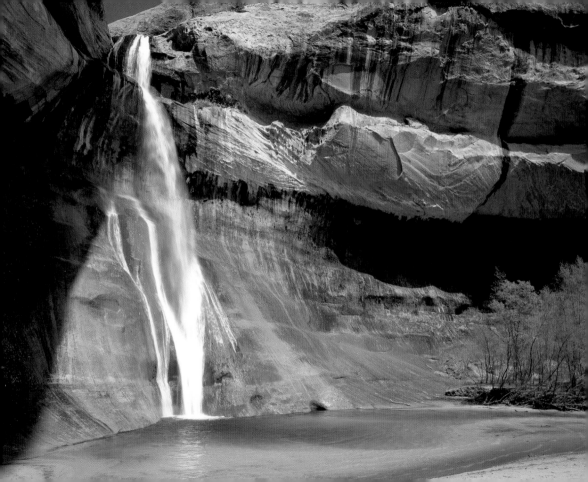

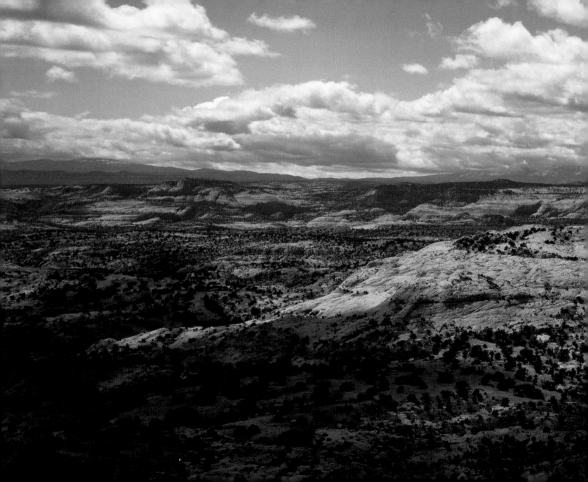

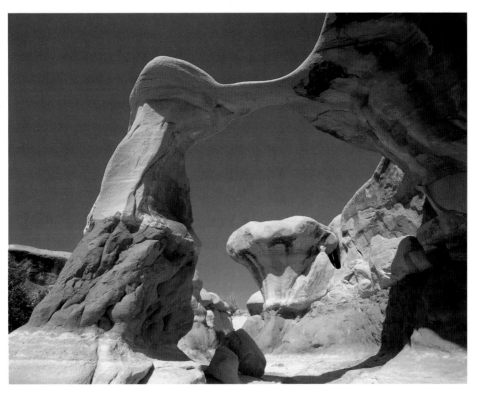

INSIDE GATEFOLD: **Headwaters of the Escalante River,** Grand Staircase-Escalante National Monument, Utah.
ABOVE: **Metate Arch, Devil's Garden,** Grand Staircase-Escalante National Monument, Utah.

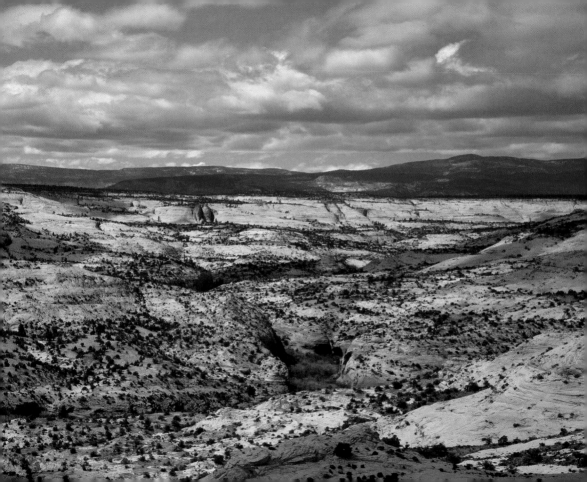

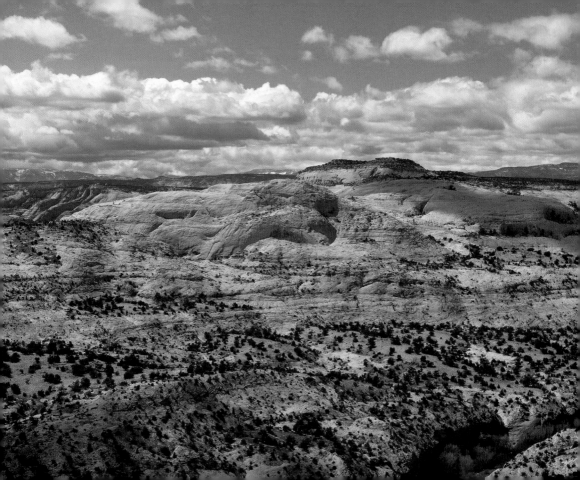

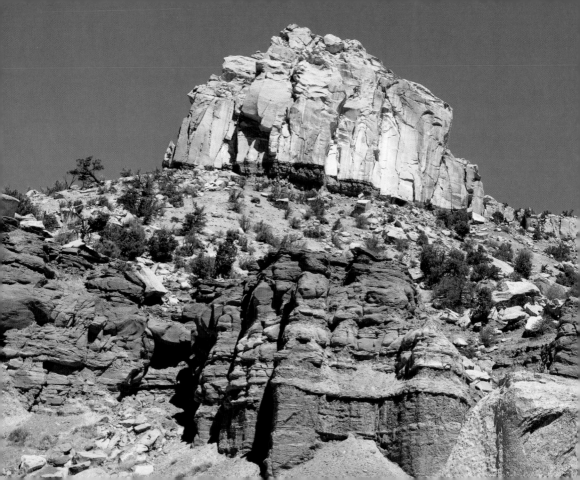

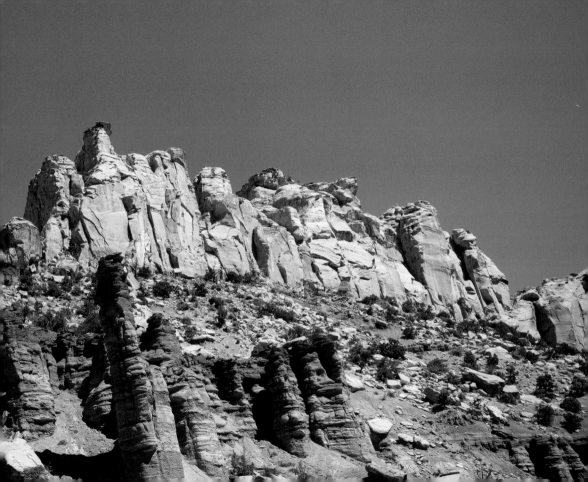

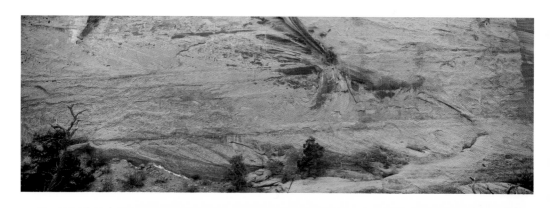

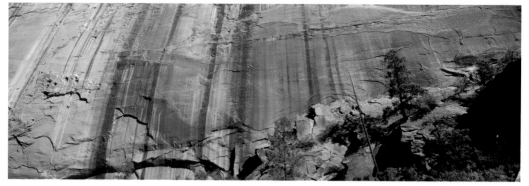

PREVIOUS AND THESE PAGES: **Long Canyon,** Grand Staircase-Escalante National Monument, Uta

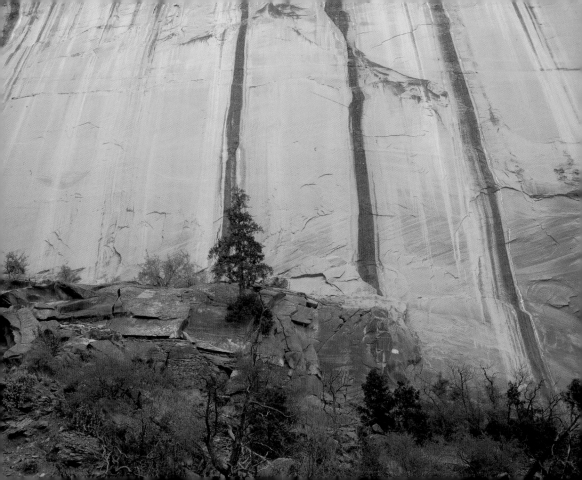

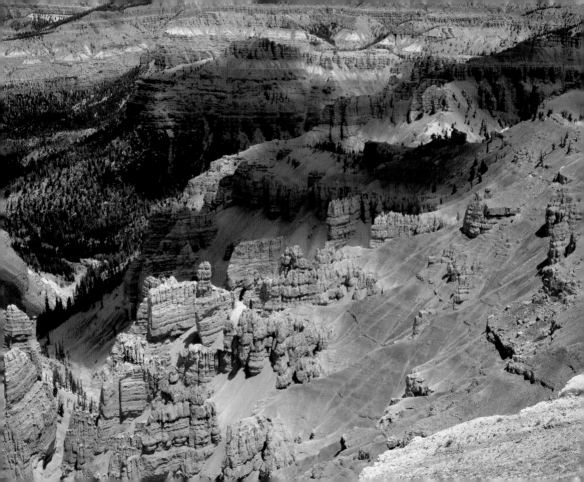

CEDAR BREAKS NATIONAL MONUMENT

UTAH

"All is a golden dream, with mysterious, high-rushing winds leaning down to caress me, and warm and perfect colors flowing before my eyes. Time and the need of time have ceased entirely. A gentle, dreamy haze fills my soul, the unreal rustling of the aspens stirs my senses and the surpassing beauty and perfection of everything fills me with quiet joy, and deep overflowing love for my world."

— EVERETT RUESS

POSITE: **Cedar Breaks Amphitheater from Ramparts Trail,** Cedar Breaks National Monument, Utah.
LLOWING PAGES: **Jericho Canyon from Point Supreme,** Cedar Breaks National Monument, Utah.

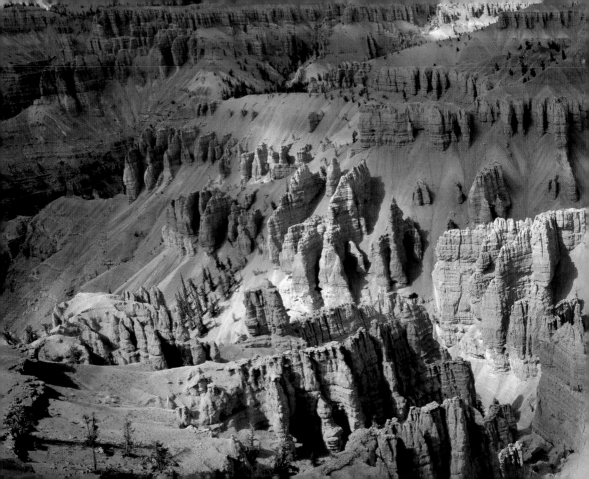

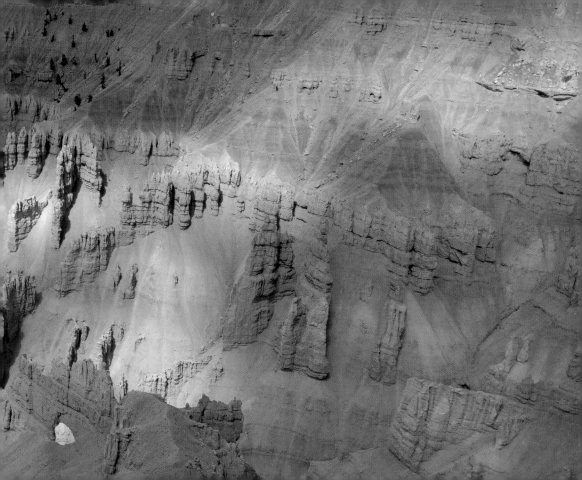

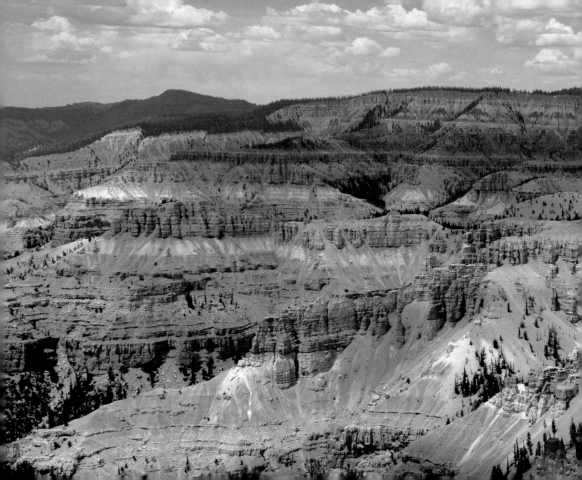

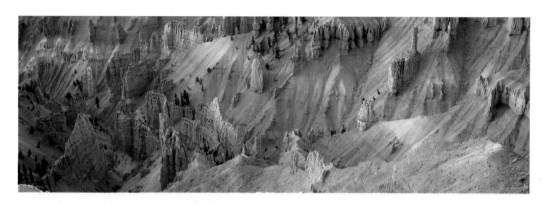

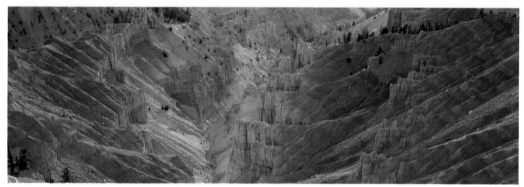

INSIDE GATEFOLD: **Cedar Breaks Amphitheater with Brian Head,** Cedar Breaks National Monument, Utah.
TOP: **Cedar Breaks Amphitheater from Point Supreme.** BOTTOM: **Cedar Breaks Amphitheater from Sunset View.**

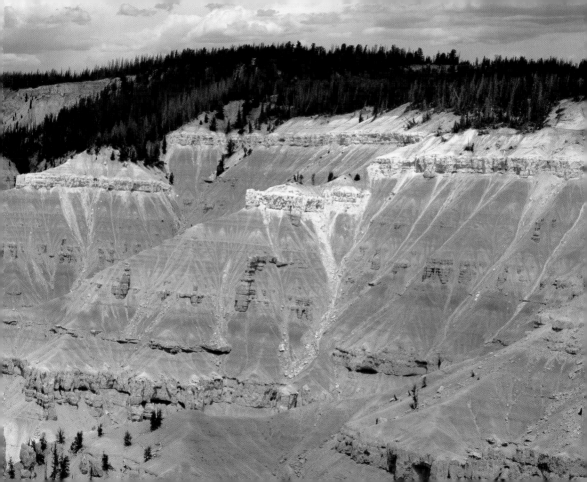

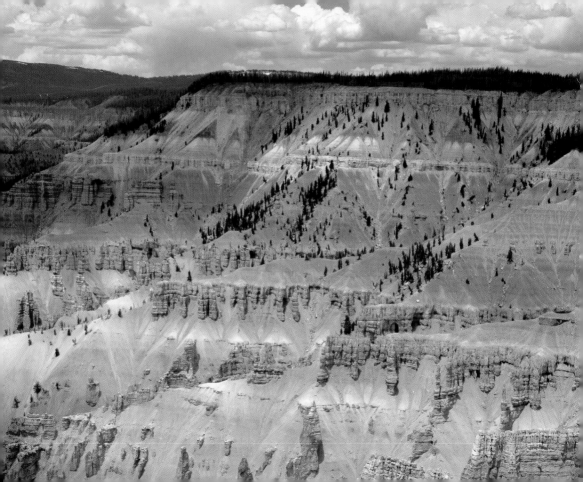

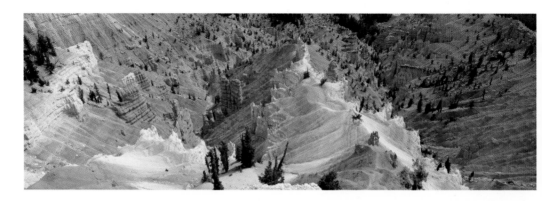

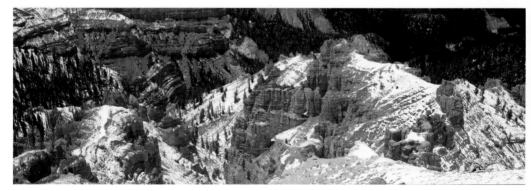

TOP: **Lavender Canyon from North View,** Cedar Breaks National Monument, Utah. BOTTOM: **Chessmen Ridge & Canyon,** Cedar Bre
National Monument, Utah. OPPOSITE: **Bristlecone Pine, Spectra Point,** Cedar Breaks National Monument, U

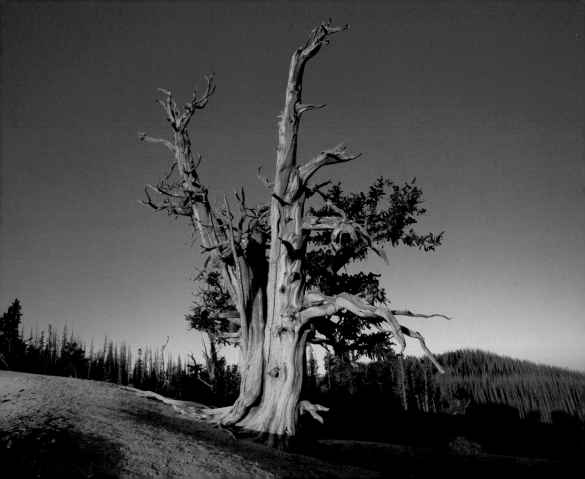

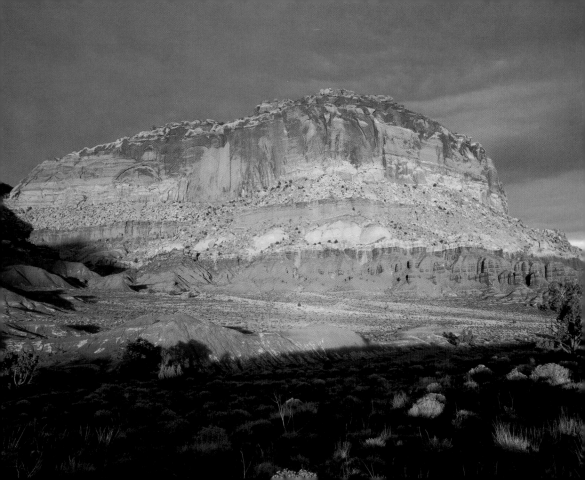

CAPITOL REEF NATIONAL PARK

U T A H

Once or twice in a lifetime (maybe more than that
 if a person is very fortunate);
In the perfect place, under conditions that may
 never occur again —
Perhaps on a mountain top with the late sun
 breaking through clouds in diffused
 radiance —
Eternity may cease its flow, the world pause,
 for one incomprehensible moment . . .
An instant in time, to be treasured forever.

— WARD J. ROYLANCE

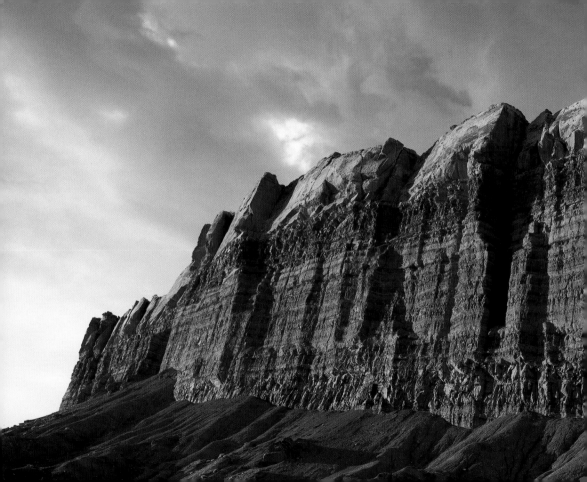

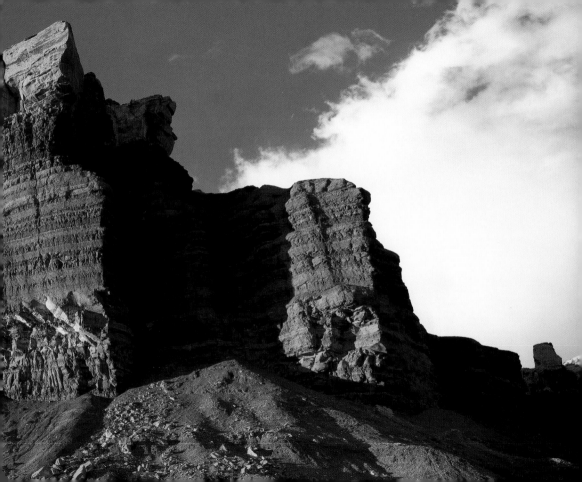

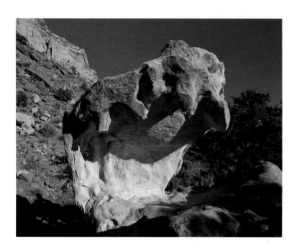

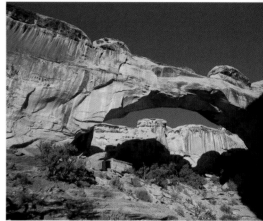

ABOVE LEFT: **Cobra Rock,** Capitol Reef National Park, Utah. ABOVE RIGHT: **Hickman Natural Bridge,** Capitol Reef National Park, Uta
OPPOSITE: **Waterpocket Fold,** Capitol Reef National Park, Uta

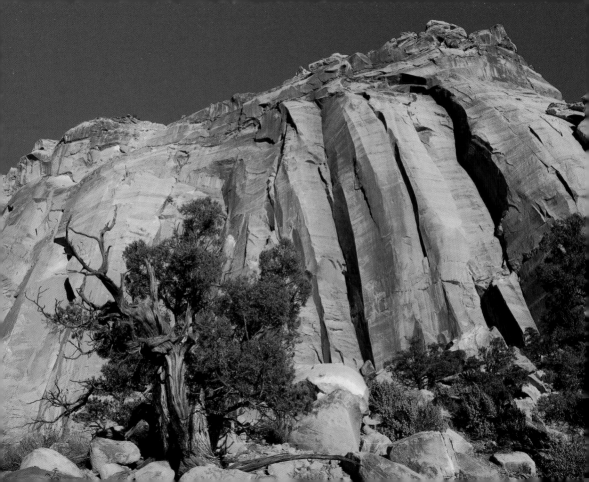

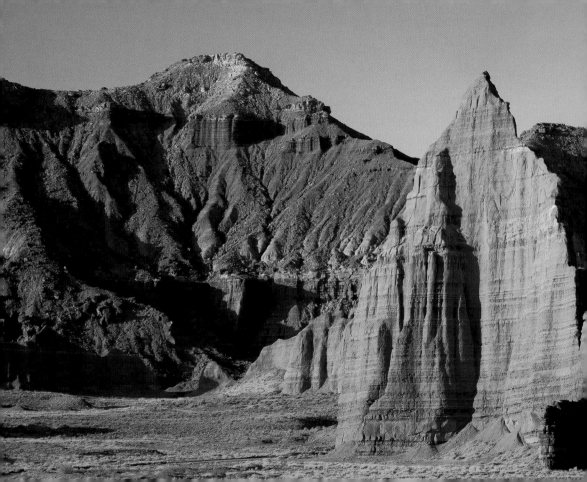

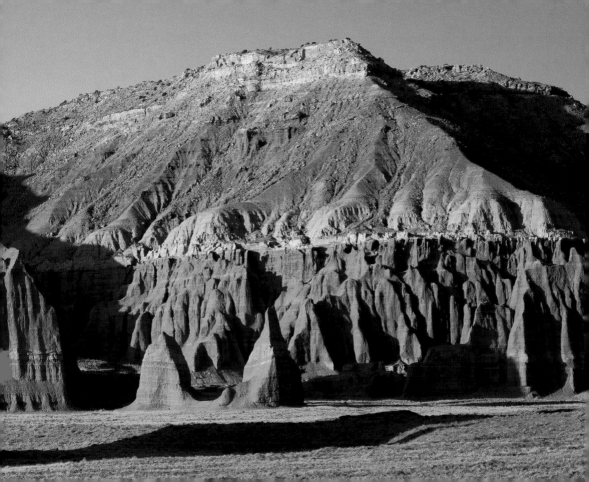

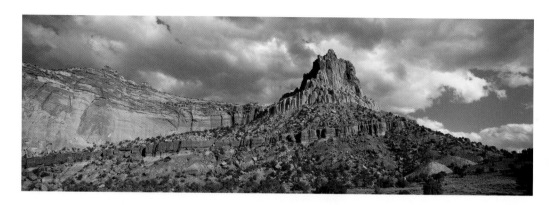

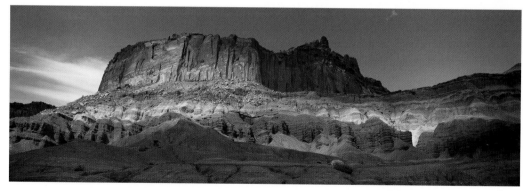

PREVIOUS PAGES: **Temple of the Moon, Lower Cathedral Valley,** Capitol Reef National Park, Uta

ABOVE: **Waterpocket Fold,** Capitol Reef National Park, Uta

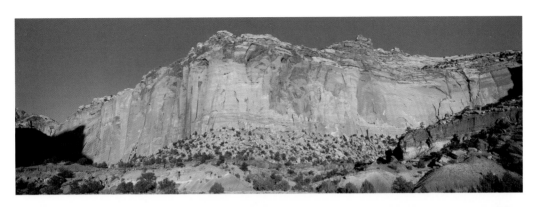

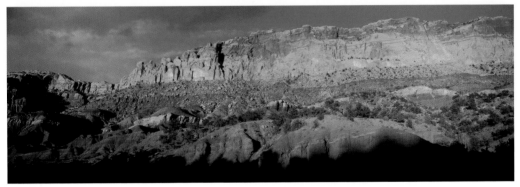

TOP: **Meeks Mesa,** Capitol Reef National Park, Utah. BOTTOM: **Waterpocket Fold,** Capitol Reef National Park, Utah. 155

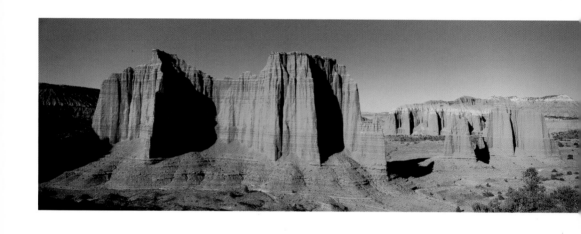

ABOVE: **Upper Cathedral Valley,** Capitol Reef National Park, Ut

OPPOSITE: **Temple of the Moon, Lower Cathedral Valley,** Capitol Reef National Park, Ut

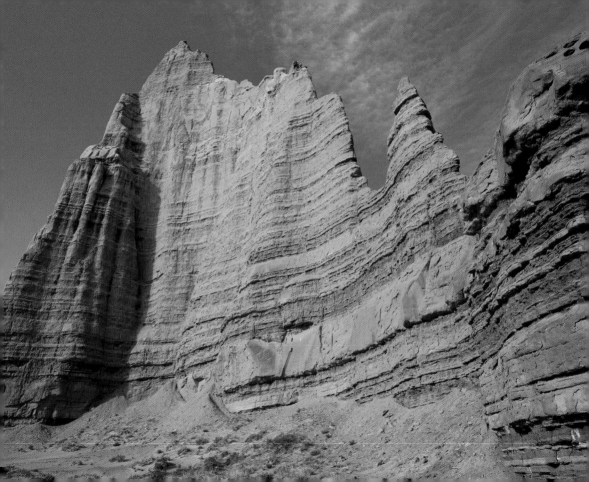

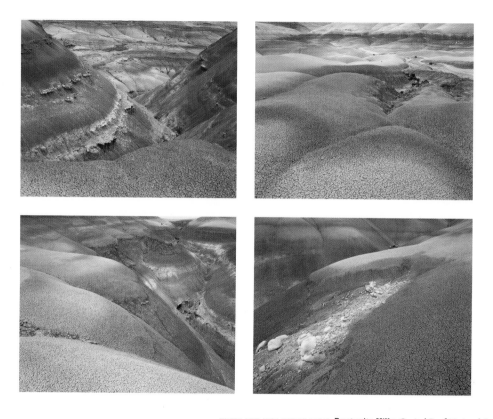

THESE AND FOLLOWING PAGES: **Bentonite Hills,** Capitol Reef National Park, Uta

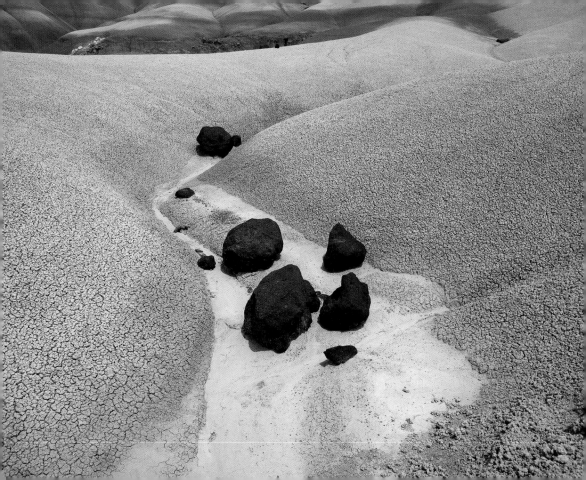

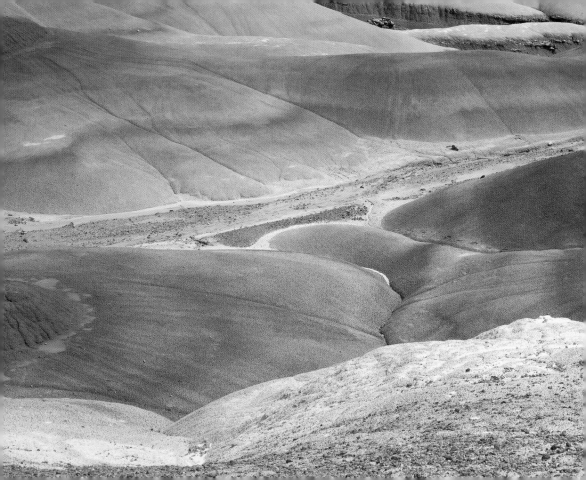

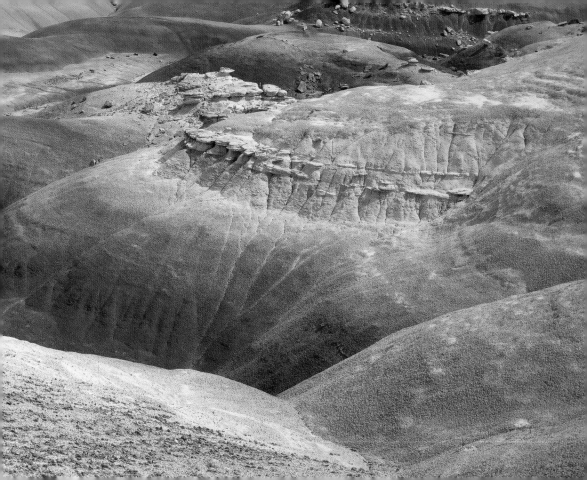

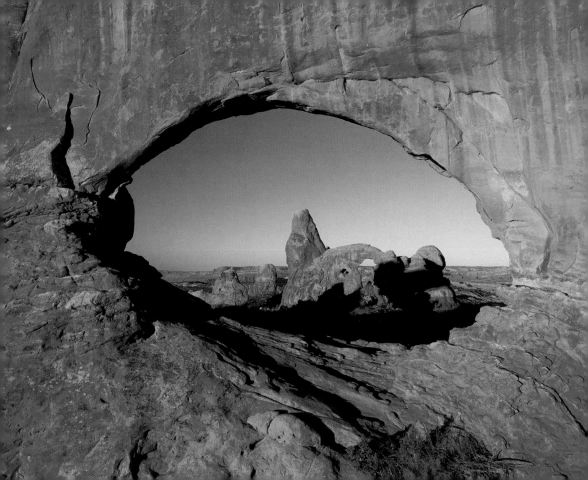

ARCHES NATIONAL PARK

U T A H

"The colors are such as no pigments can portray. They are deep, rich, and variegated and so luminous are they that the light seems to flow out of the rock rather than to be reflected from it."

— CLARENCE E. DUTTON

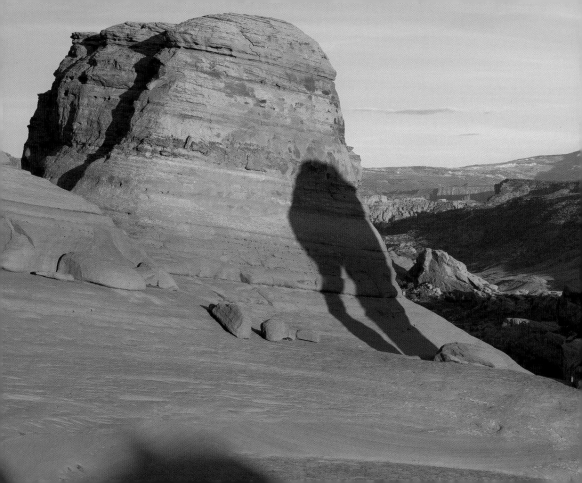

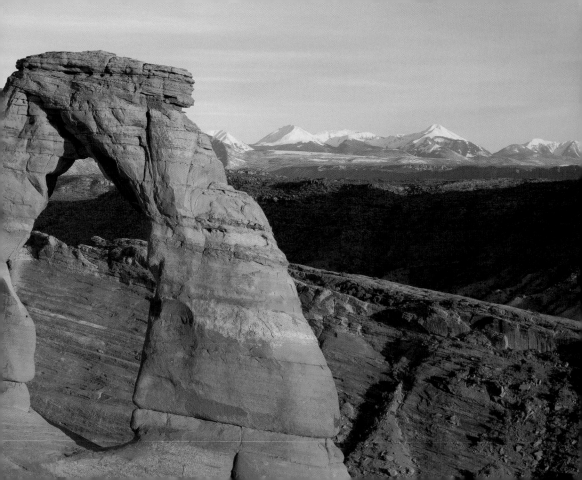

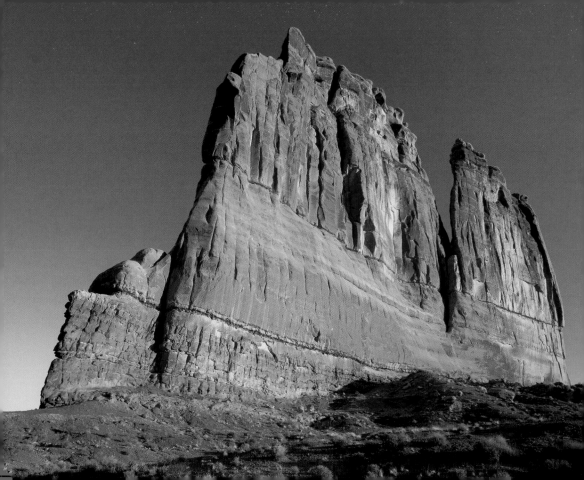

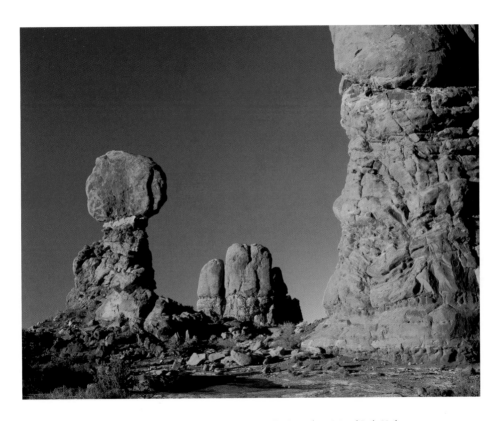

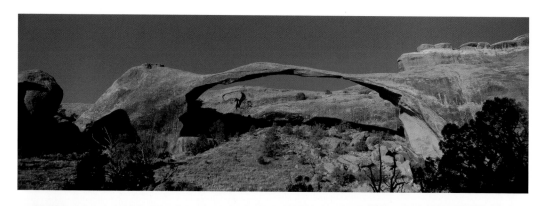

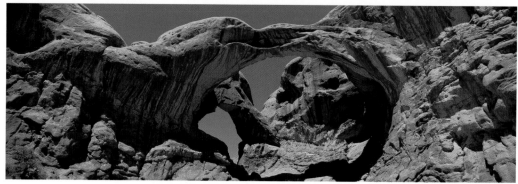

TOP: **Landscape Arch,** Arches National Park, Utah. BOTTOM: **Double Arch,** Arches National Park, Uta

OPPOSITE: **Broken Arch,** Arches National Park, Uta

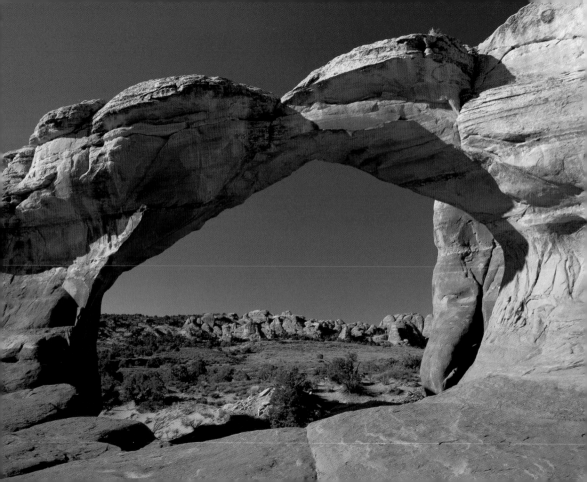

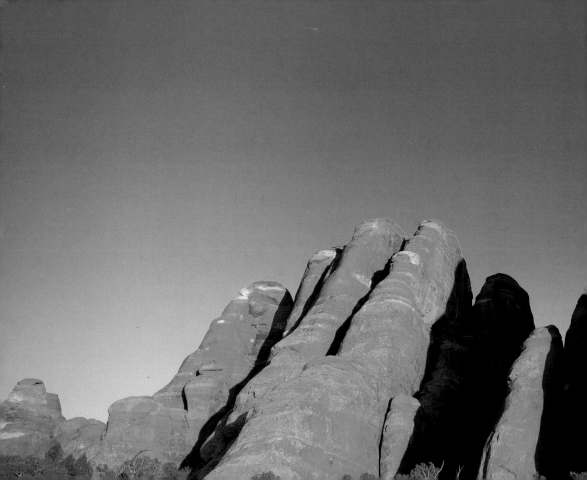

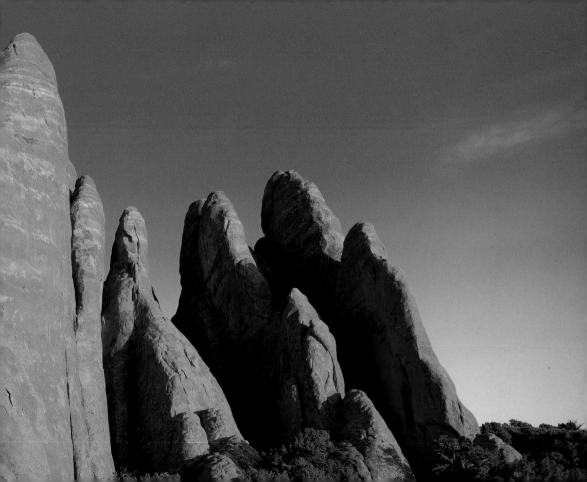

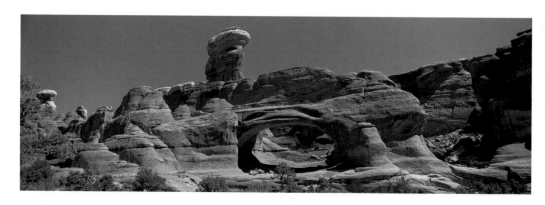

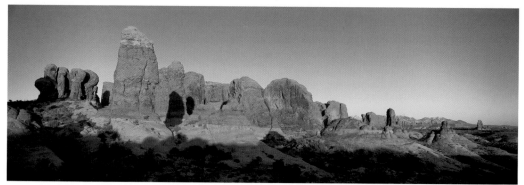

PREVIOUS PAGES: **Fins,** Arches National Park, Utah. TOP: **Tower Arch, Klondike Bluffs,** Arches National Park, Ut
BOTTOM: **Garden of Eden,** Arches National Park, Ut

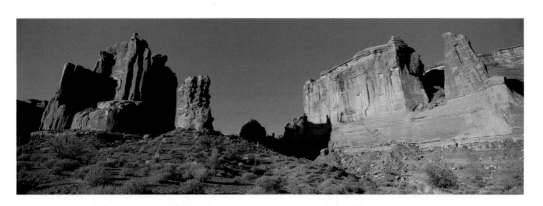

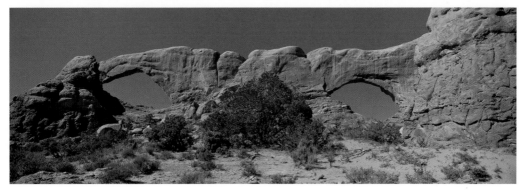

TOP: **Courthouse Towers,** Arches National Park, Utah. BOTTOM: **The Windows,** Arches National Park, Utah.

173

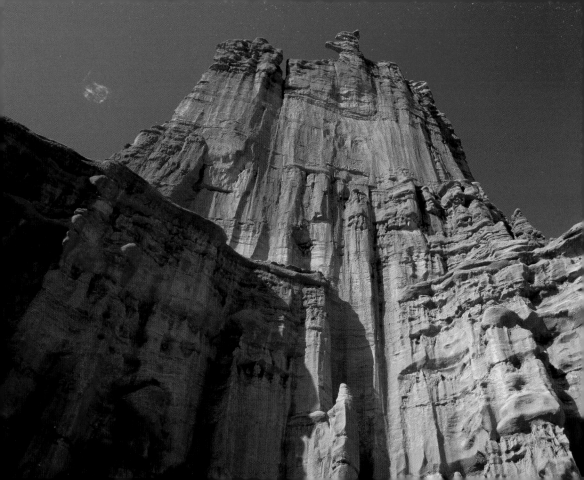

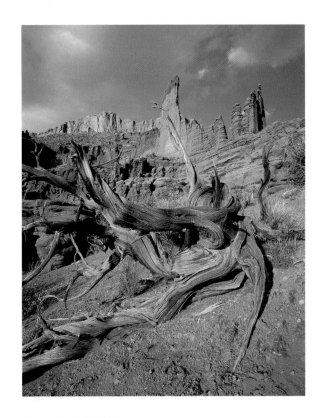

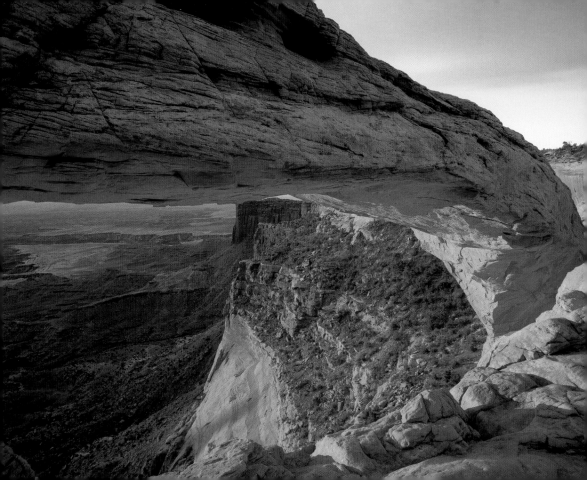

CANYONLANDS NATIONAL PARK

U T A H

"I love the grim gaunt edges of the rocks, the great bare backbone of the earth, rough brows and heaved-up shoulders, round ribs and knees of the world's skeleton protruded in lonely places."

— MAYNARD DIXON

OPPOSITE: **Mesa Arch,** Canyonlands National Park, Utah. FOLLOWING PAGES (178–79): **Monument Basin from Grand View Point,** Canyonlands National Park, Utah. FOLLOWING PAGES (180–81): **Mesa Arch,** Canyonlands National Park, Utah.

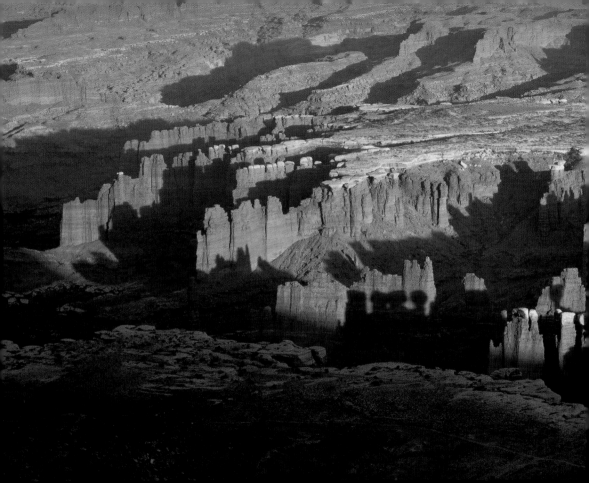

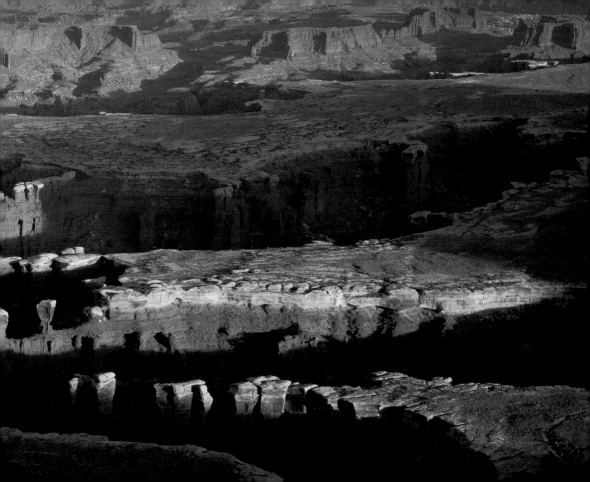

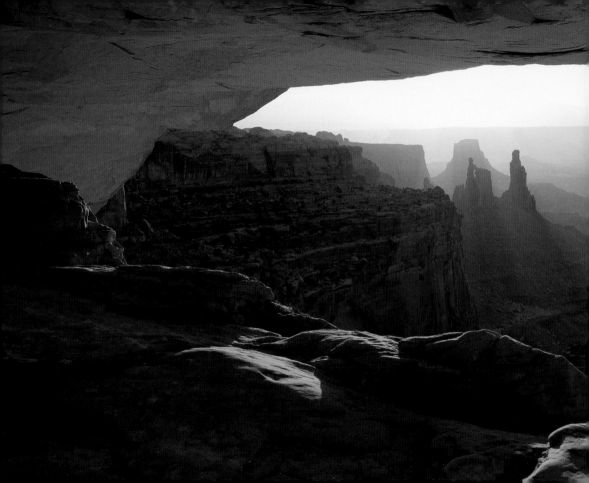

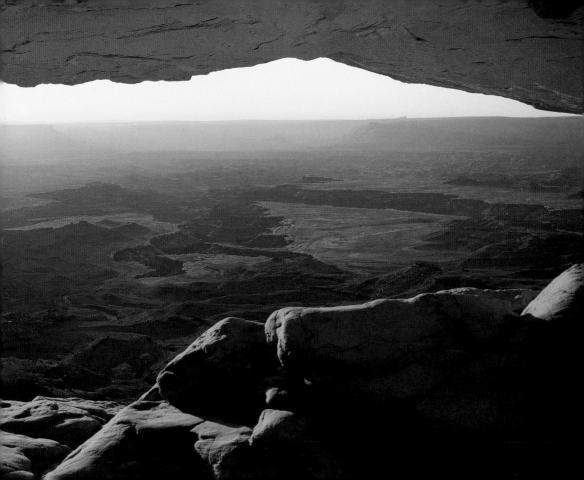

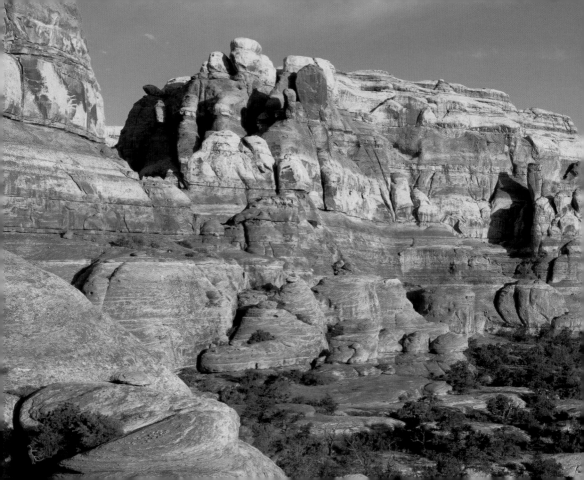

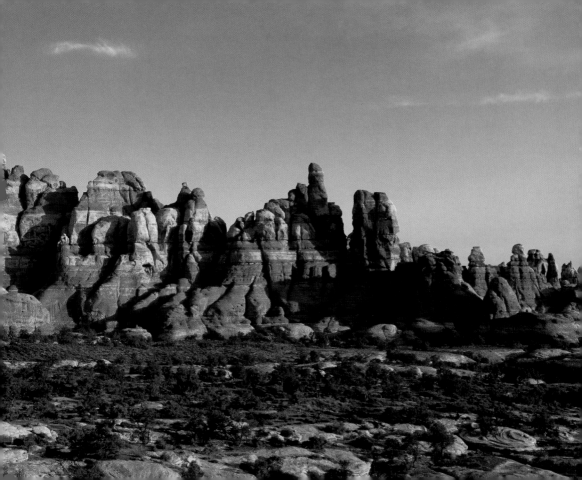

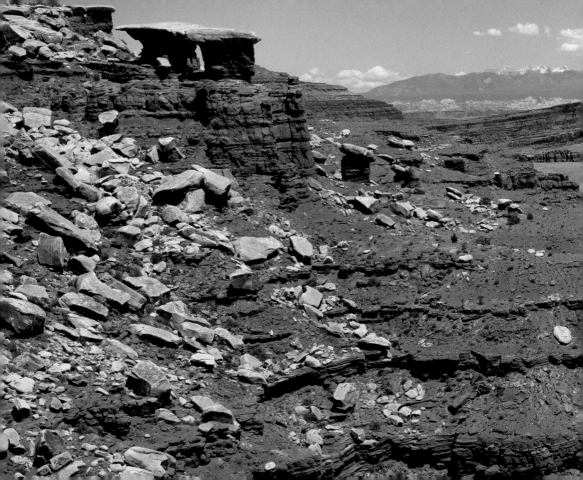

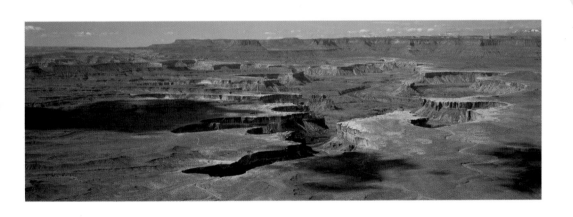

PREVIOUS PAGES: **Needles, near Chesler Park,** Canyonlands National Park, Utah.
INSIDE GATEFOLD: **White Rim,** Canyonlands National Park, Utah. ABOVE: **Green River Overlook,** Canyonlands National Park, Utah.

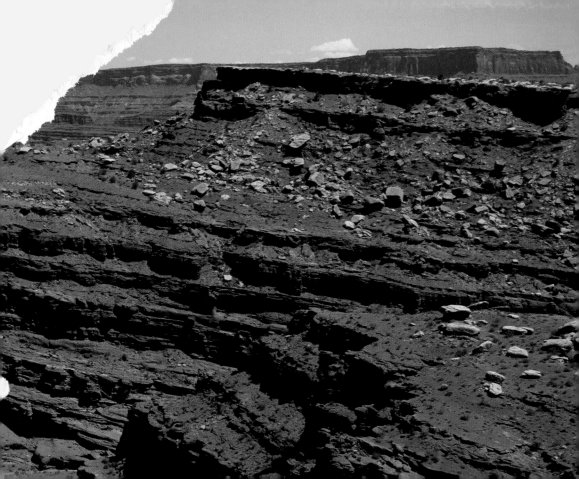

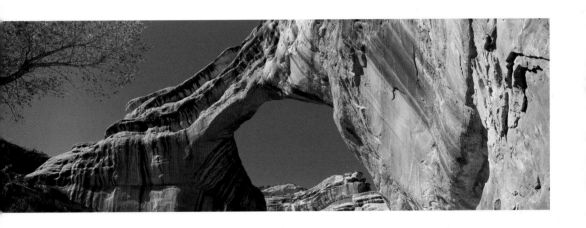

ABOVE: **Sipapu Natural Bridge,** Natural Bridges National Monument, Utah. FOLLOWING PAGES: **Goosenecks of the San Juan State Park,** Utah.

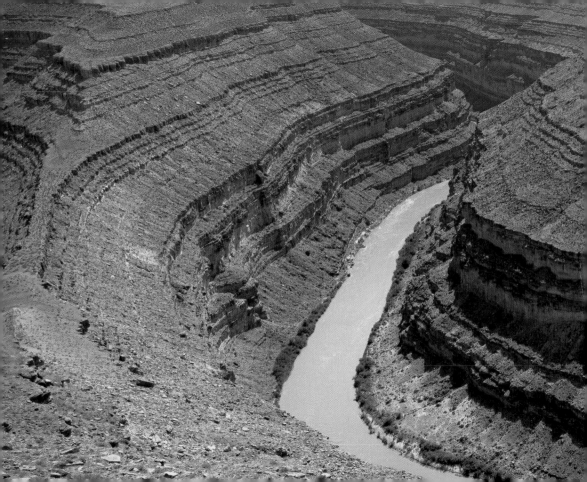

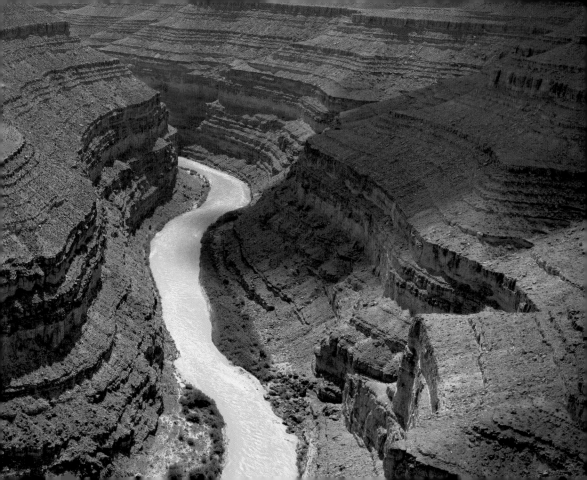

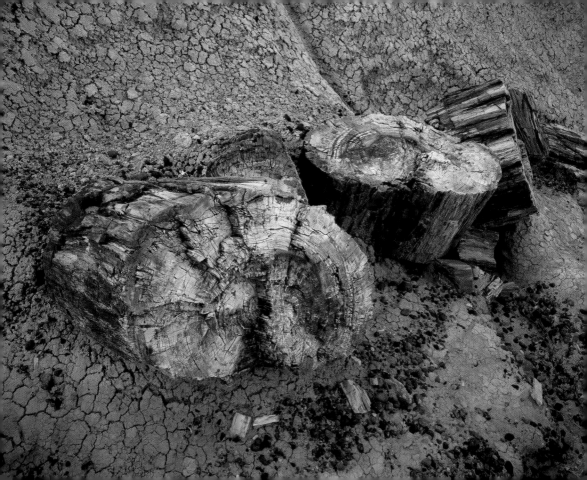

PETRIFIED FOREST NATIONAL PARK

A R I Z O N A

"What you come to see on the surface is not what you come to know. Emptiness in the desert is the fullness of space, a fullness of space that eliminates time. The desert is time, exposed time, geologic time. One needs time in the desert to see."

— TERRY TEMPEST WILLIAMS

etrified Wood, Blue Mesa, Petrified Forest National Park, Arizona.

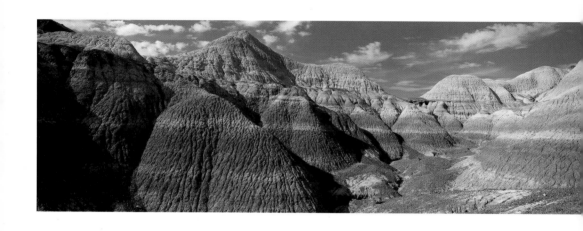

ABOVE: **Blue Mesa,** Petrified Forest National Park, Arizona. OPPOSITE: **Petrified Wood, Blue Mesa,** Petrified Forest National Park, Arizona

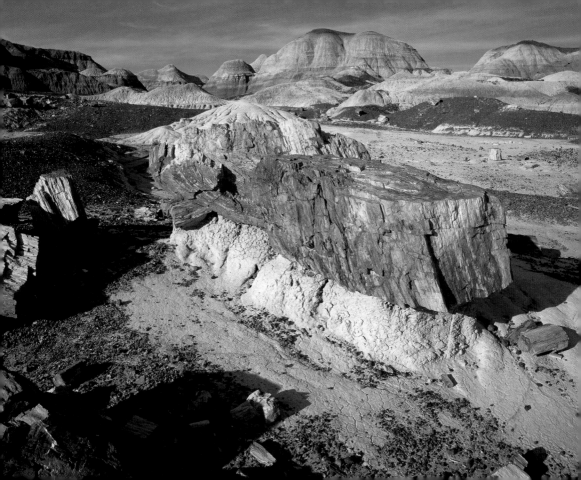

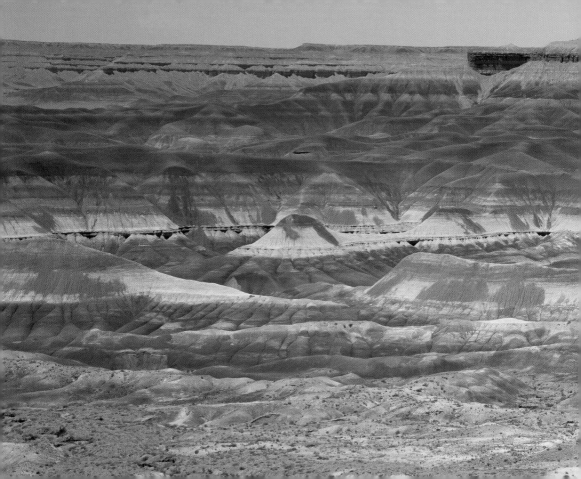

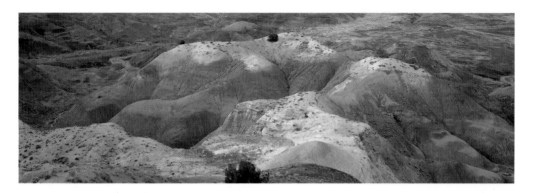

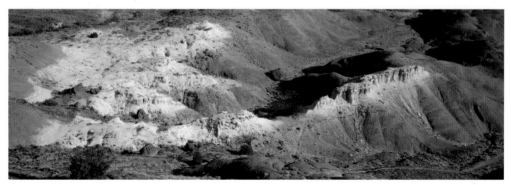

INSIDE GATEFOLD: **Little Painted Desert,** Petrified Forest National Park, Arizona.　ABOVE: **Painted Desert Wilderness Area,**
Petrified Forest National Park, Arizona.　PAGES 200–201: **Blue Mesa,** Petrified Forest National Park, Arizona.
PAGES 202–203: **Puerco Ridge,** Petrified Forest National Park, Arizona.

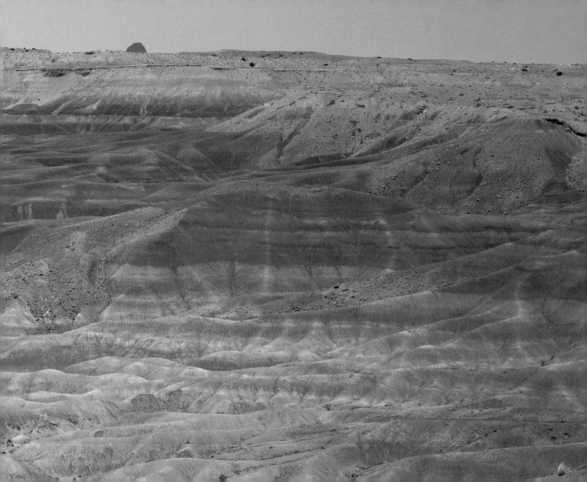

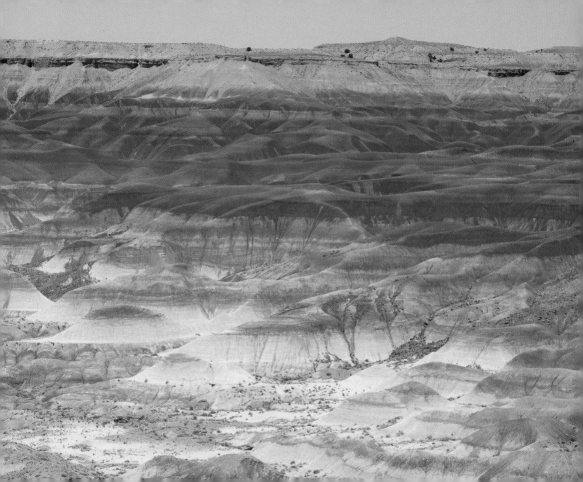

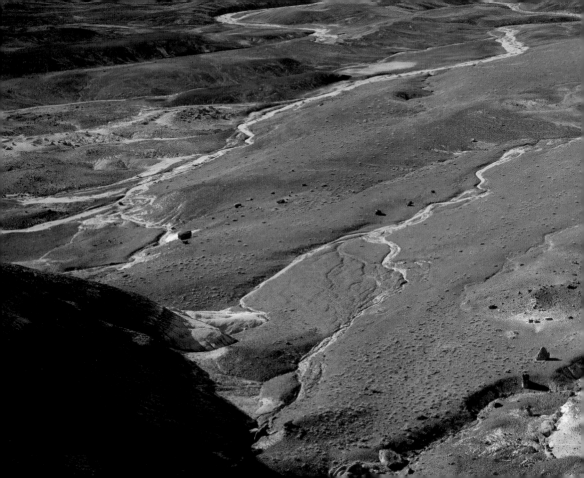

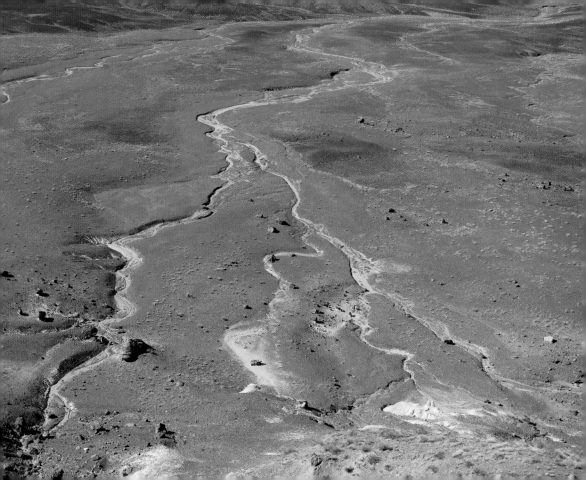

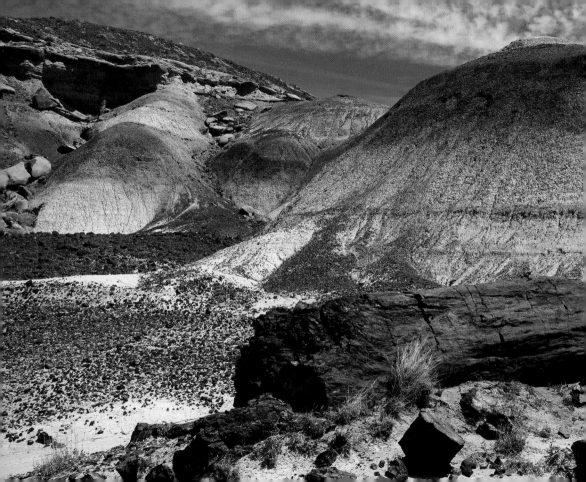

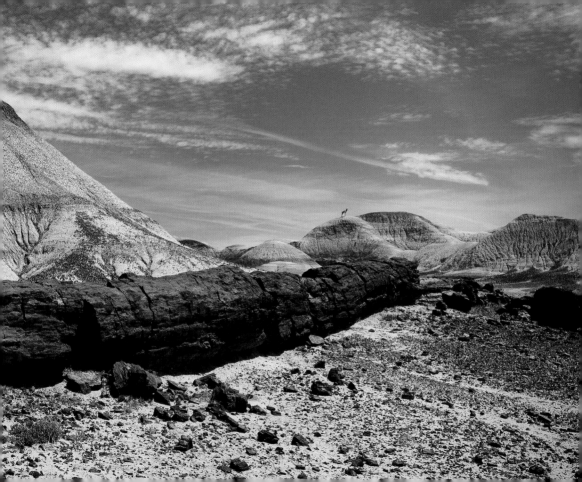

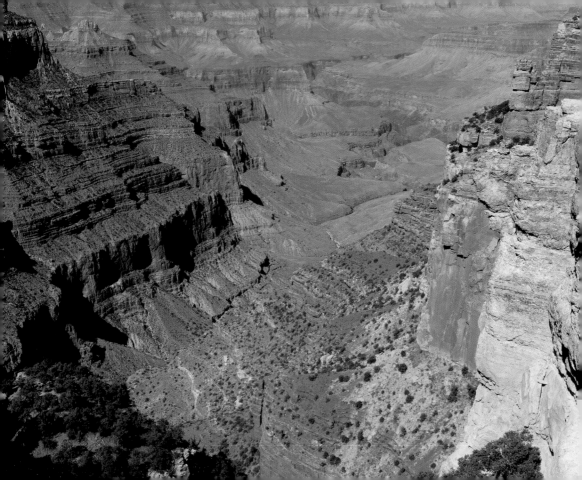

GRAND CANYON NATIONAL PARK

ARIZONA

"It has infinite variety, and no part is ever duplicated. Its colors, though many and complex at any instant, change with the ascending and declining sun; lights and shadows appear and vanish with the passing clouds, and the changing seasons mark their passage in changing colors."

— JOHN WESLEY POWELL

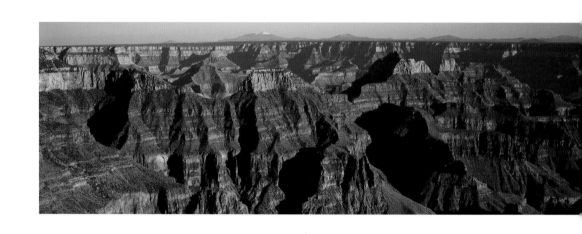

Bright Angel Point, North Rim, Grand Canyon National Park, Arizo

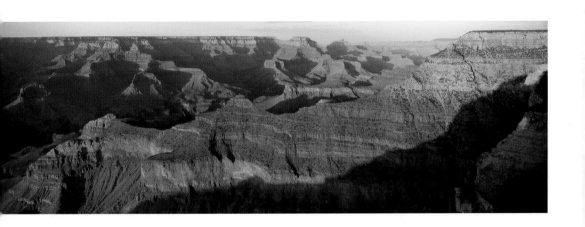

ᴏᴠᴇ: **Mather Point, South Rim,** Grand Canyon National Park, Arizona.
ᴏʟʟᴏᴡɪɴɢ ᴘᴀɢᴇꜱ: **Cape Royal, North Rim,** Grand Canyon National Park, Arizona.

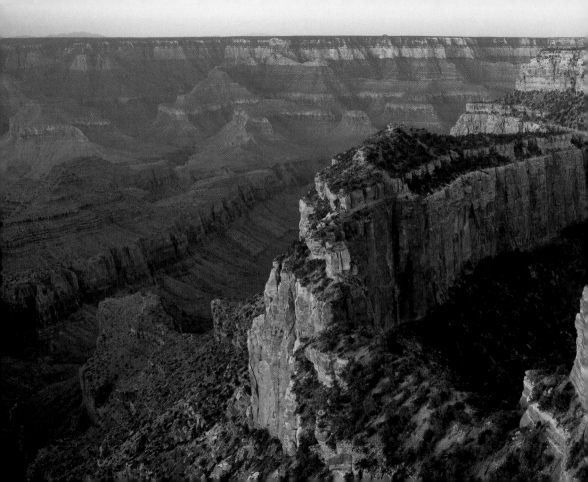

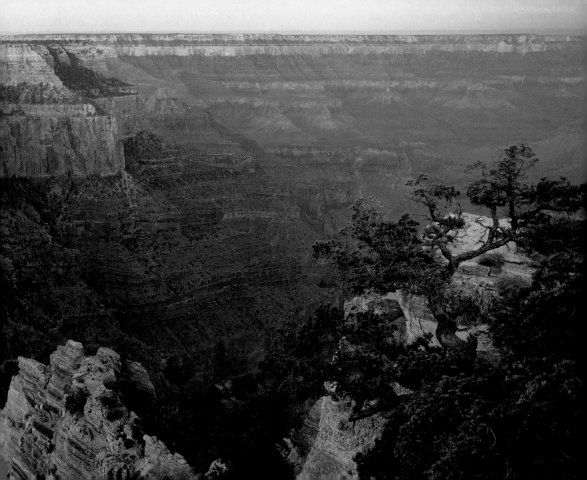

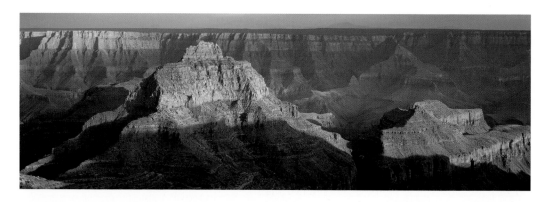

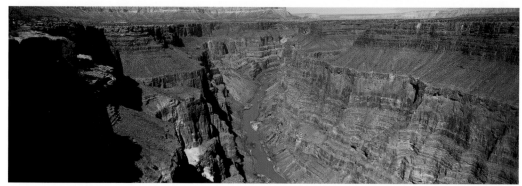

TOP: **Cape Royal, North Rim,** Grand Canyon National Park, Arizo[na]
BOTTOM: **Toroweap, North Rim,** Grand Canyon National Park, Arizo[na]

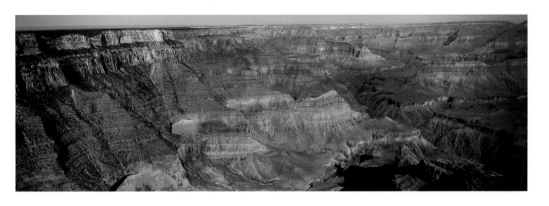

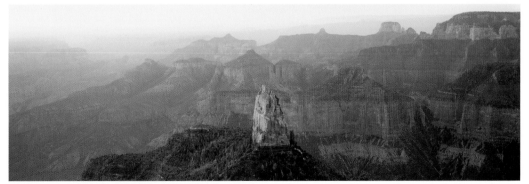

TOP: **Mohave Point, South Rim,** Grand Canyon National Park, Arizona.
BOTTOM AND FOLLOWING PAGES: **Point Imperial, North Rim,** Grand Canyon National Park, Arizona.

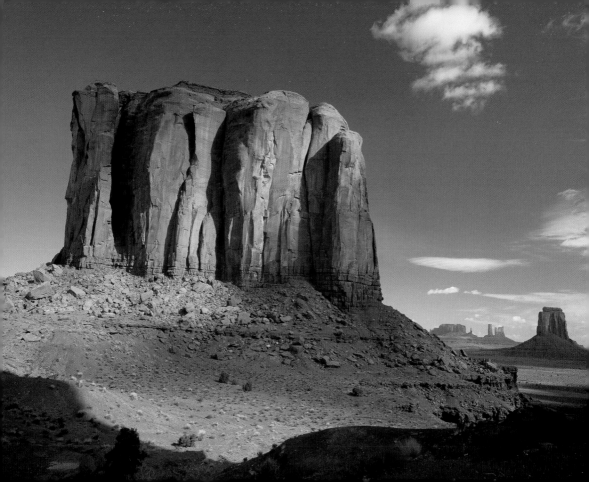

NATIVE AMERICAN TRIBAL LANDS

A R I Z O N A / U T A H

"In this glare of brilliant emptiness, in this arid intensity of pure heat, in the heart of a weird solitude, great silence and grand desolation, all things recede to distances out of reach, reflecting light but impossible to touch, annihilating all thought and all that men have made to a spasm of whirling dust far out on the golden desert."

— EDWARD ABBEY

e **North Window,** Monument Valley Navajo Tribal Park, Arizona.

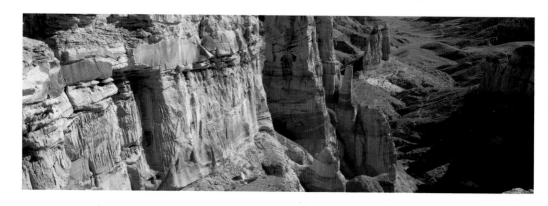

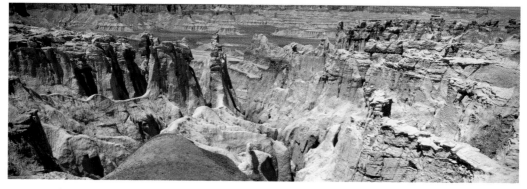

TOP: **Honooji Canyon,** Hopi Indian Reservation, Arizona. BOTTOM AND OPPOSITE: **Ho Ho No Geh Canyon,** Hopi Indian Reservation, Arizo

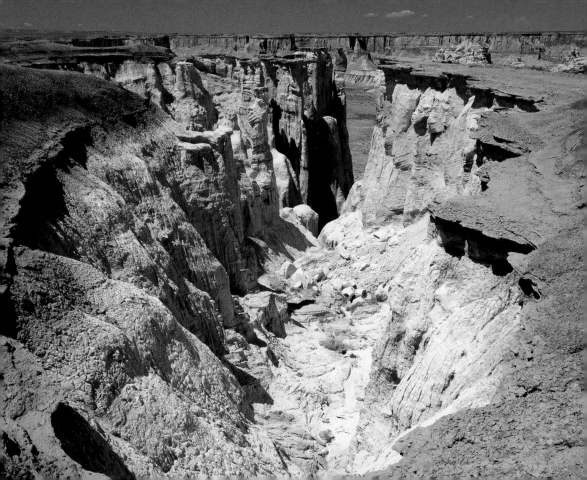

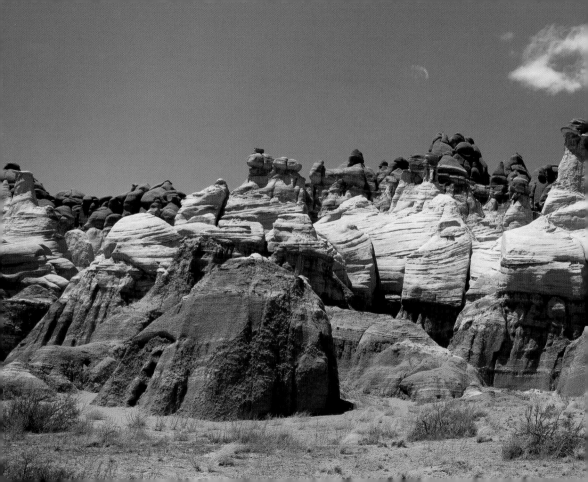

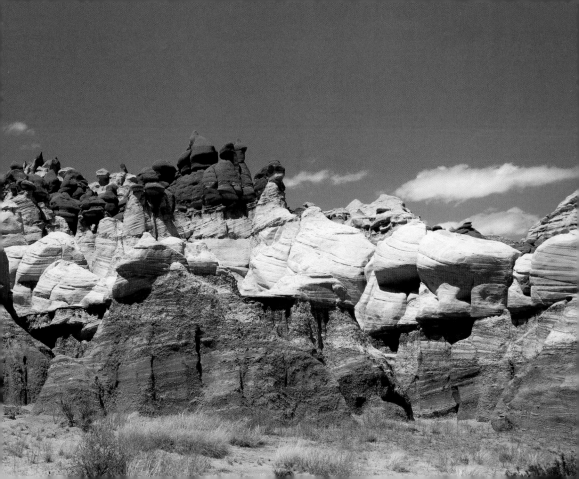

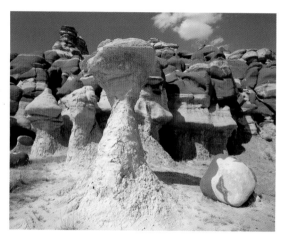
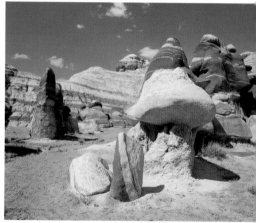

PREVIOUS AND THESE PAGES: **Moenkopi Wash,** Hopi Indian Reservation, Ariz

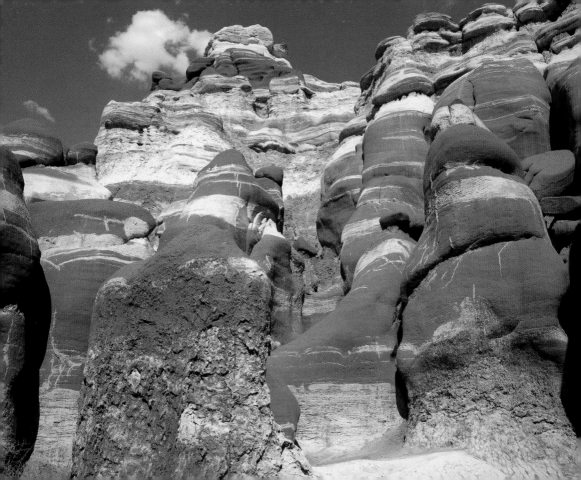

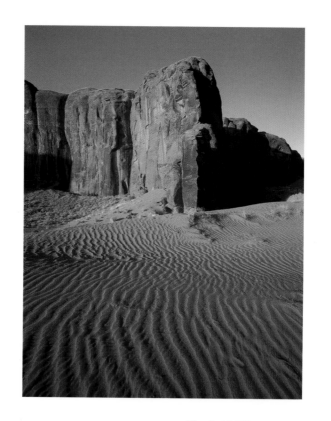

Thunderbird Mesa, Monument Valley Navajo Tribal Park, Arizo

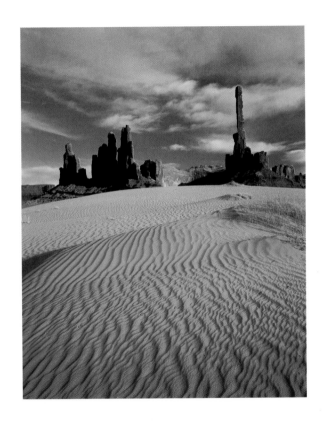

Bi Chei and The Totem Pole, Monument Valley Navajo Tribal Park, Arizona.

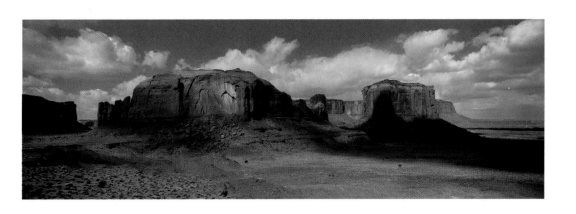

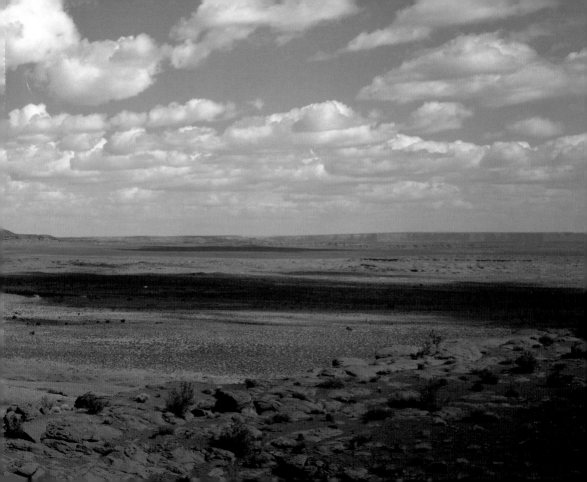

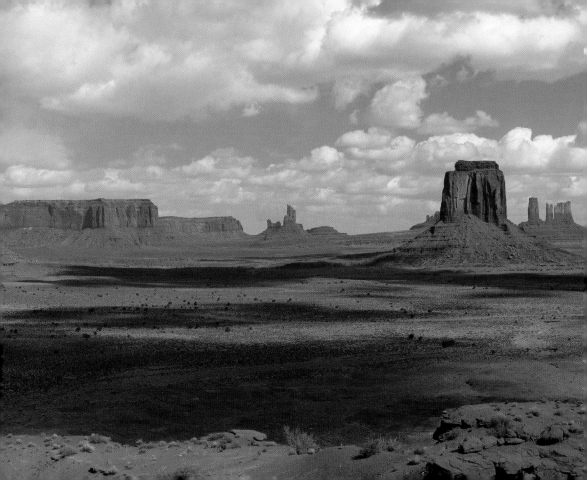

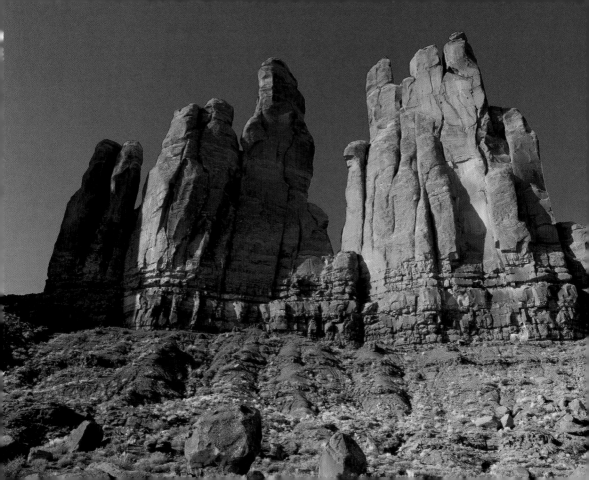

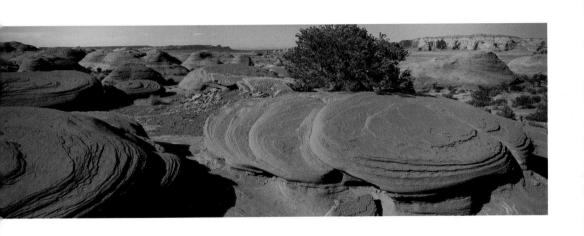

OPPOSITE: **Yei Bi Chei,** Monument Valley Navajo Tribal Park, Arizona. ABOVE: **Mystery Valley,** Monument Valley Navajo Tribal Park, Arizona.

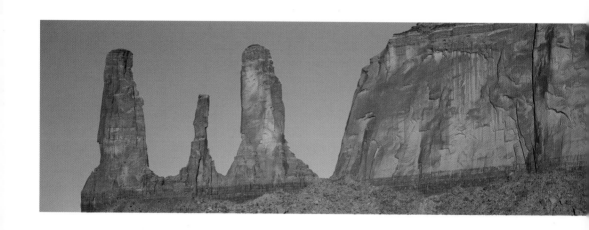

ABOVE: **Three Sisters & Mitchell Mesa,** Monument Valley Navajo Tribal Park, Arizona
OPPOSITE: **Rain God Mesa,** Monument Valley Navajo Tribal Park, Arizona

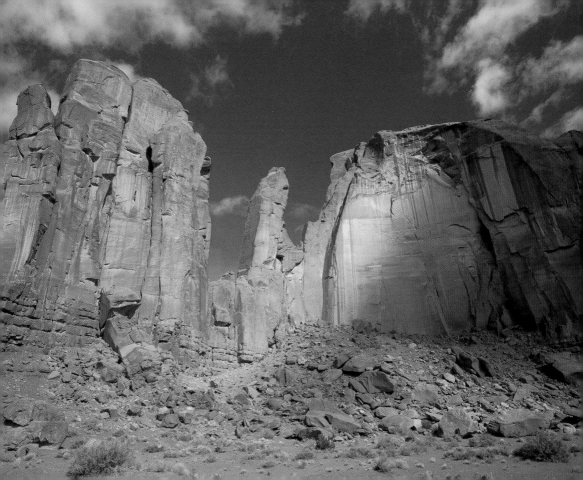

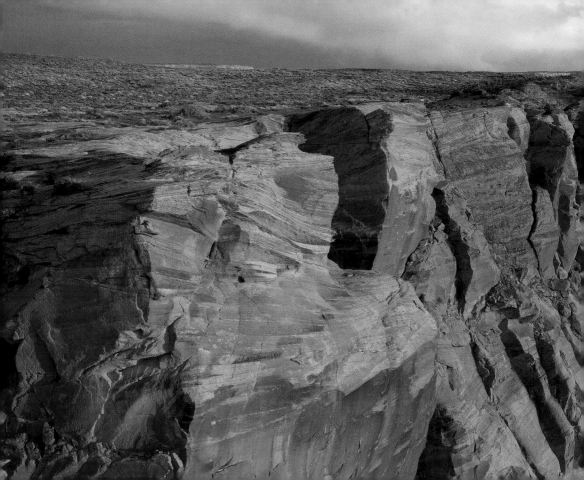

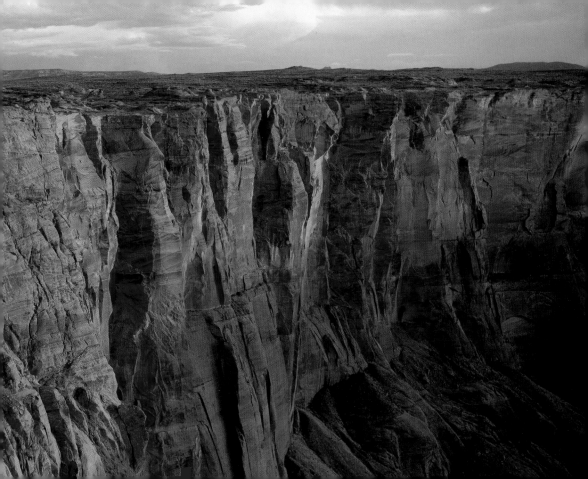

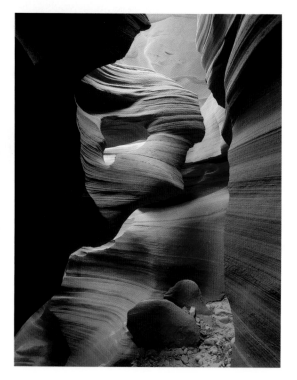
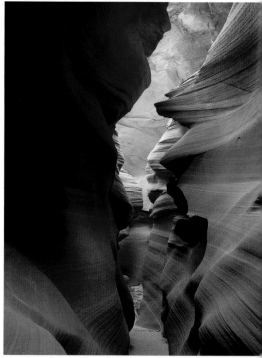

PREVIOUS PAGES: **Horseshoe Bend of the Colorado River**, Arizona.　THESE PAGES: **Antelope Canyon Navajo Tribal Park**, Arizo

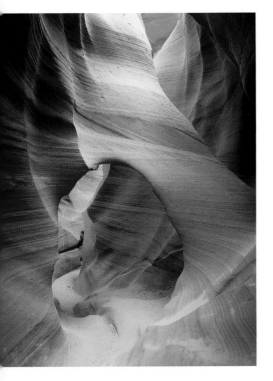

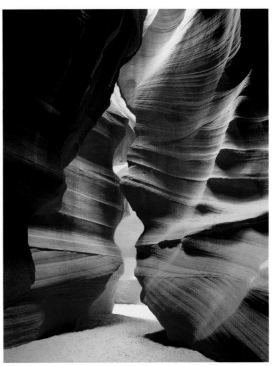

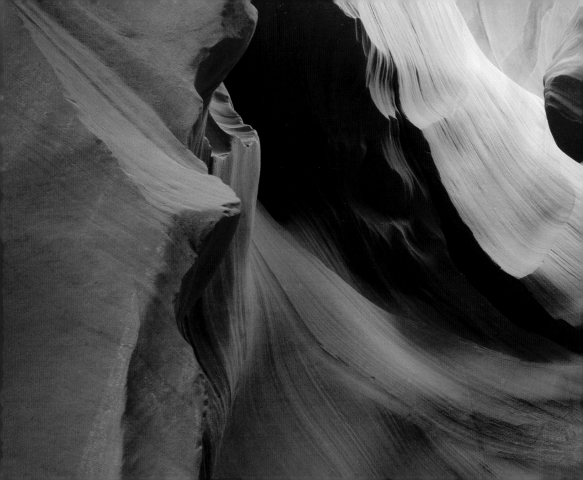

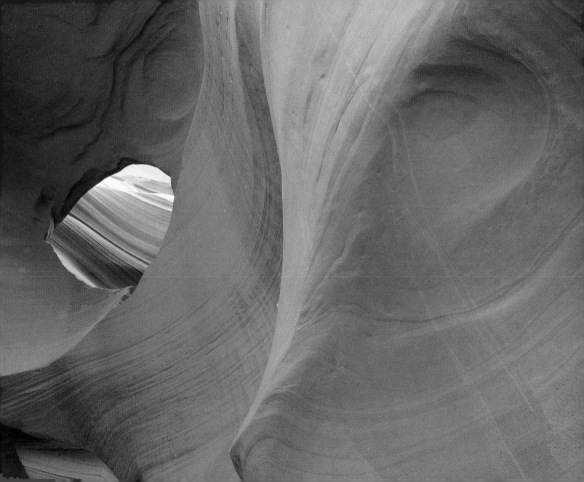

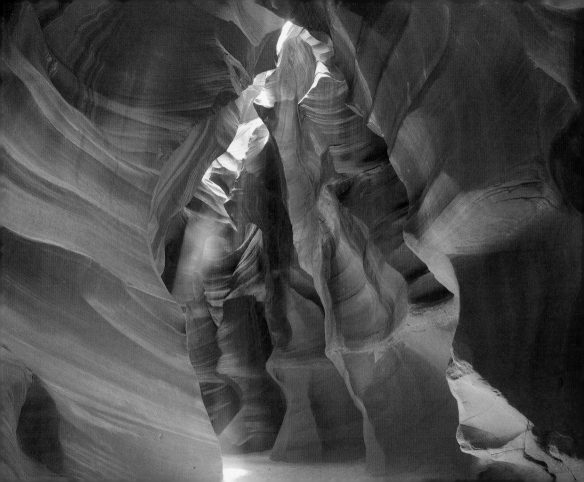

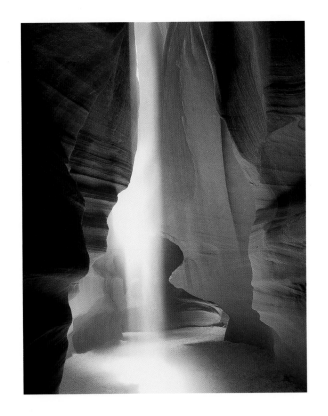

EVIOUS AND THESE PAGES: **Antelope Canyon Navajo Tribal Park,** Arizona.

239

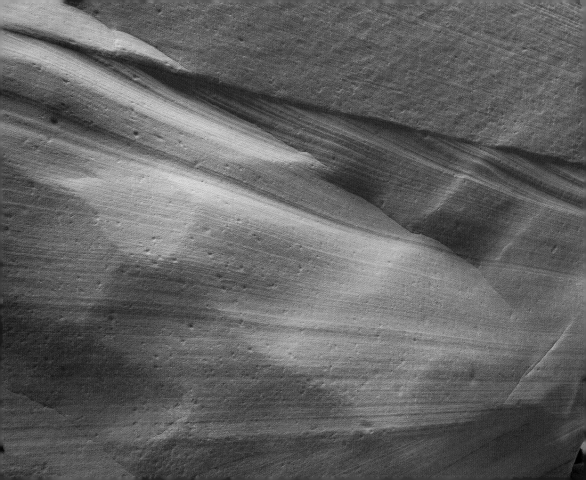

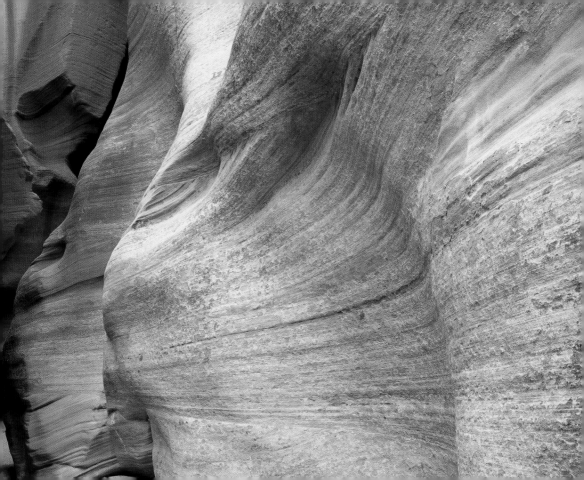

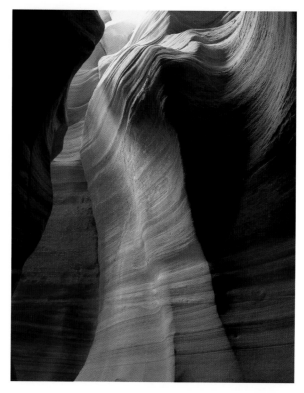

PREVIOUS AND THESE PAGES: **Canyon X,** Navajo Indian Reservation, Ariz⬤
FOLLOWING PAGES: **Rainbow Bridge,** Rainbow Bridge National Monument, U⬤

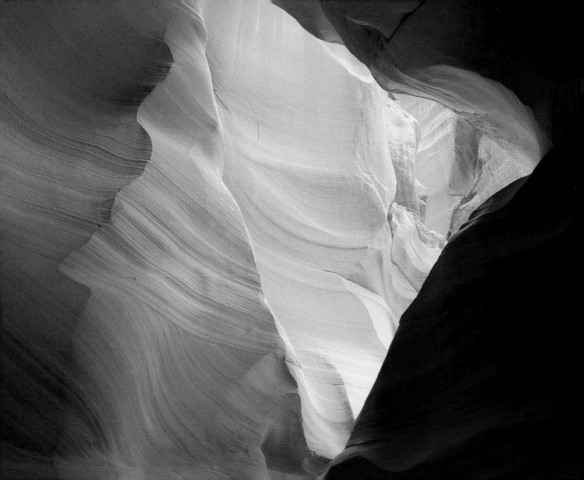

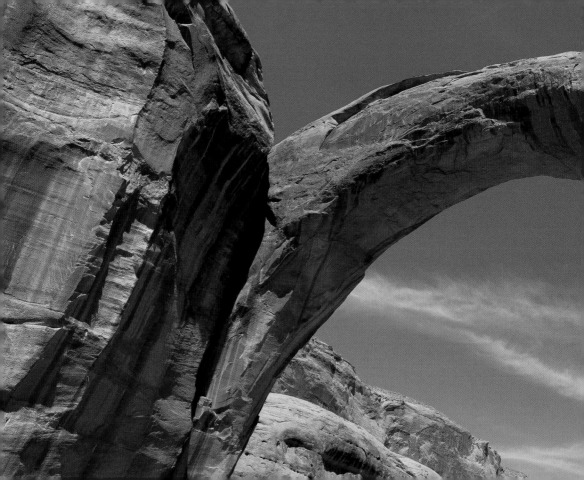

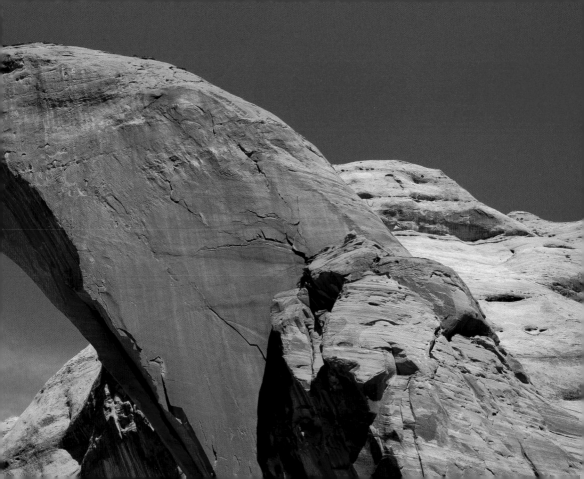

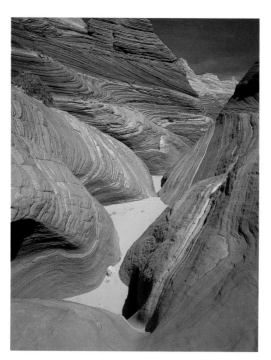

Sand Cove, Paria Canyon-Vermilion Cliffs Wilderness, Arizona.

NOTES ABOUT SELECTED LOCATIONS AND PHOTOGRAPHS

Jon Ortner

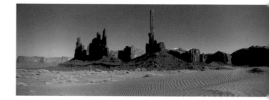

PAGES 10–11: **Yei Bi Chei and The Totem Pole,** Monument Valley Navajo Tribal Park, Arizona.

On the eastern edge of Monument Valley is a serie of soaring rock towers. Twenty-five-million-year-old-sentinels, they are sacred and important symbc of the Navajo spirit world. One, known as the Totem Pole, is an impossibly slender rock spire tha majestically rises 400 feet from the desert. A red, solitary pinnacle defying gravity, it stands guard ove

of shifting sand dunes and dramatic buttes. Another group of formations, adjacent to this, is own in the Navajo language as *Yei Bi Chei*, after ritual line of dancers of the Navajo Nightway aling Ceremony. On the ninth and last night of ceremony, the Navajo Talking God appears, aring the mask of the *Yei*, and leads the *Yeibichei* ncers through the night as they bestow blessings on a patient.

Because of the sanctity of this particular site, all itors must be accompanied by a Navajo guide. vas a privilege to spend my morning visit with rold Simpson. Harold's great, great grandfather s Grey Whiskers, and his family was one of the ginal families that lived in Monument Valley 'ore Hollywood discovered it and the recent rise ourism.

We arrived in the dark, well before dawn, and ;an hiking up into the dunes to be in place for irise. As I set up my equipment, the rippled waves sand began to glow and I heard the haunting sound a Navajo flute. In the distance, I could just make t Harold sitting cross-legged on a huge boulder.

His delicate notes wafted and echoed among the cliffs. The soft morning breeze, the smell of sage and juniper, and the overpowering beauty of the dunes and monoliths created a perfect confluence. As if in a dream, I truly felt the power of this spiritually charged place, making it one of the most beautiful mornings of my life. SEE ALSO PAGES 223, 228, AND 278.

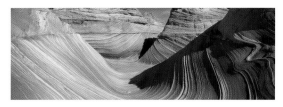

PAGES 28–29: **The Wave,** Paria Canyon-Vermilion Cliffs Wilderness, Arizona.

The Paria Canyon-Vermilion Cliffs Wilderness comprises remnants of the largest desert ever to evolve on the planet. Two hundred million years ago, this desert stretched from central Wyoming to southern Nevada, rivaling the Sahara in size. Immense sand dunes accumulated over a period of

10 to 20 million years. As the huge dunes shifted and moved in response to changing wind directions, tilted beds formed, and cross-stratification occurred.

Uplift and erosion exposed the petrified dunes, revealing a natural masterpiece of swirling lines and eccentric shapes. Minerals that cement the clear quartz grains together also tint the layers of sandstone brilliant red, orange, purple, and magenta.

Created in 1984, the Wilderness preserves 112,500 acres, including portions of the Paria Plateau, the Paria River Gorge, and the spectacular rock wonderland of the Coyote Buttes. SEE ALSO PAGES 1, 246, AND BACK JACKET.

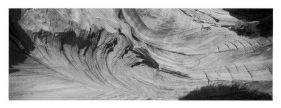

PAGES 38–39: **Cottonwood Cove,** Paria Canyon-Vermilion Cliffs Wilderness, Arizona.

The immense Paria Plateau is rimmed on its entire southern end by the sheer walls of the Vermilion Cliffs—so large that they can be observed from a satellite—while on the north it is bounded by the gorges of the Paria and Buckskin Rivers. To the northwest rise the Coyote Buttes. A 10-mile line of heavily eroded peaks—some close to 6,000 feet in elevation—they are an extension of the faulted and uplifted Cockscomb.

Although it became part of the National Wilderness system in 1984, the Coyote Buttes were virtually unknown until 1995, when an article came out in a German magazine describing the strangely shaped and colored rock sculptures found there. Its popularity exploded, and by 1997, the BLM, in an effort to protect the extremely fragile formations, had instituted a quota system restricting visitation 20 people per day.

Similar to Coyote Buttes North, the southern section contains spectacular and rare examples of eroded Navajo sandstone weathered into an almost infinite variety of twisted, contorted, and polished shapes, including petrified sand dunes, fins, polygon

nting, teepees, arches, caverns, and crossbedded
krock, all colored by mineral inclusions in hues
vivid yellow, orange, red, and lavender.

One of the more interesting areas of the south
tion is Cottonwood Cove. Named for a small
ing with a single cottonwood tree nearby, it is
owl-shaped depression surrounded by cliffs on
ee sides. Essentially trail-less, exploration of this
note region requires good maps, food, water, and
eful preparation. A huge area, it becomes even
ger as soon as you start to hike the rugged terrain.
our spring visit, we left Page, Arizona, at 3:30 A.M.
d arrived at Cottonwood Cove in the dark. We
hed to get our packs on and walked quickly for
ut a mile in the deep sand. We arrived at the first
mation—a petrified sand dune similar to the
ave but of a deep yellow color with concentric
irled patterns—and set up our cameras just in time
the first rays of sunrise. We were rewarded
h an unforgettable experience, as the delicate
dstone fins glowed with an intensity that was truly
d to believe.

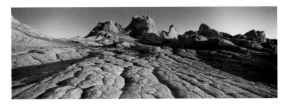

PAGE 45: **White Pocket,** Vermilion Cliffs National
Monument, Arizona.

Hidden among the dunes and dry washes of a vast
desert plain in a remote region of the Paria Plateau
is a small miracle of nature. Once only known to a
few ranchers, White Pocket has now rightly ascended
the throne as one of the premier wonders of the
mineral world.

At first glance, it appears as a fairly ordinary region
of whitish depressions and small dome-shaped hills.
But upon closer examination scenes of amazing
beauty begin to unfold. A surreal and strange "rock
garden" nestles at the base of a massive white butte
at an elevation of more than 6,000 feet. Spread
out in front of you are hundred of acres of bare
slickrock that has unaccountably crystallized into a

vast, undulating pavement. Incredibly smooth and puffy-looking, as if slightly inflated, these striking geometrically fitted rock segments are technically called *polygonal jointing*, and occur when surface layers of Navajo sandstone expand and contract in areas of crossbedding.

Where this top layer of white stone has eroded away, a deeper red layer bleeds through, creating strange organic-looking "brain rocks" and spectacular whirlpool-like structures in which colored bands have been twisted and braided together. Other features have been encased with strange root-like tendrils, lacey veins that appear to be alive and almost growing. Rarer still, and incredibly fragile, are the fields of iron concretions known as *moquis*, which have eroded out of the sandstone substratum and over thousands of years have been washed and blown into intricate patterns among the polygons.

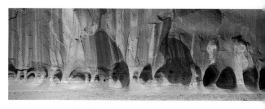

PAGES 54–55: **Paria River Narrows,** Paria Canyon-Vermilion Cliffs Wilderness, Utah.

Just outside of Page, Arizona, is what is considered to be the longest, narrowest, and deepest slot canyon in the world. Every year, from mid-July to mid-September, monsoonal rainstorms send an average of eight flash floods racing down the Paria River, continuing the process that created this spectacular formation. The canyon extends from the White House trailhead to Lee's Ferry, where the Paria joins the great Colorado River—a distance of approximately 39 miles. Countless streams flow into gullies and washes funneling into canyons like the Paria. Over the eons, these floods have worn through the Pink Cliffs and Navajo sandstone, creating passageways deep into the earth.

Draining the huge amphitheaters of Bryce Canyon more than 40 miles away, the Paria's surging floodwaters descend from 10,000 feet, picking up tremendous energy in the process and becoming a powerful cutting force of suspended mud, gravel, and boulders. Each subsequent flood scours and re-creates the streambed, making every visit to the canyon unique.

The largest tributary of the Paria is the Buckskin. Beginning at Wire Pass trailhead you descend into a rocky streambed and the canyon quickly narrows, sometimes to only shoulders' width. For the next 13 miles it is dark and twisting, with only a small strip of blue sky visible overhead. At the majestic confluence of the Paria and Buckskin, the walls tower 500 feet above, and show the impacts and fractures of countless cataclysmic floods. There, in the deepest recesses, the sun illuminates the canyon floor for only a few hours each day, giving brief sustenance to small, verdant patches of maple and box elder, extraordinary oases in a world of sheer rock and raging water.

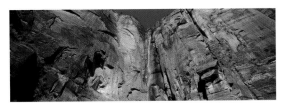

PAGES 68–69: **Waterfall at Temple of Sinawava,** Zion National Park, Utah.

Zion National Park is located in the southwestern corner of Utah. A landscape of high plateaus and deeply incised canyons, the region was occupied by the Anasazi Basket Makers from A.D. 500 to about 1200.

In the 1860s, Mormon pioneers arrived and built homesteads, displacing the Paiute Indian occupants. Impressed with Zion Valley's flowing waters, verdant forests, and abundant game, the new settlers named it for a chapter in the Bible (Isaiah 2), which mentions a place called Zion, "where the Lord's house shall be. . . in the top of the mountains."

Zion's Navajo sandstone layer is massively thick, which has led to the creation of gigantic sheer canyon

walls. Over millions of years, the Virgin River has worn down through 2,400 feet of the Markagunt Plateau, forming the Zion Narrows, one of the most awe-inspiring slot canyons in the world.

Designated a national monument in 1909, then upgraded to a national park in 1919, Zion, at only 147,000 acres, is relatively small as national parks go. Yet, it is filled with world-class natural wonders. SEE ALSO PAGE 14.

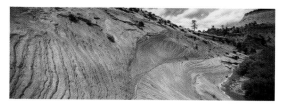

PAGES 72–73: **Clear Creek Canyon,** Zion National Park, Utah.

At the western edge of the Colorado Plateau, 15 million years of uplift and erosion have created a land of narrow canyons and towering sandstone cliffs. Preserved in the 229-square-mile Zion National Park, this region contains some of the most dramatic and breathtaking landscapes in North America.

Characterized by vast areas of contorted crossbedding, the spectacular canyon at Clear Creek, one of the tributaries of the Virgin River, is surrounded by huge buttes of Navajo sandstone, so rising over 7,000 feet. Like those found in Vermilic Cliffs Wilderness, the areas of crossbedding are the remnants of petrified sand dunes; but in Zion, erosi has further etched the successive layers along the planes of deposition, giving the 140-million-year-o formations especially deep and beautifully etched striations. Iron oxide is slowly leaching out of the sandstone, giving rise to delicate swirling patterns o pink, yellow, and tan.

With 15 to 20 inches of rain per year, Zion receiv more water than any other national park in Utah. Clear Creek, although prone to devastating flash floods, manages to protect and nourish small luxuria groves of Fremont cottonwood, box elder, and gamb oak. The steep slopes of the canyon are almost completely devoid of vegetation, but on top of the high plateaus, mature stands of Ponderosa pine thriv

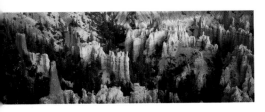

PLATE 83: **Peek-A-Boo Loop Trail,** Bryce Canyon
National Park, Utah.

has been described as a rare oasis of beauty in
the desert and as a fairyland of rainbow-hued and
exquisitely sculpted rock spires. Eroded into the
western escarpment of the Paunsaugunt Plateau, Bryce
Canyon is one of the most spectacular geological
formations of the West. At only 38,835 acres, it
is Utah's smallest national park; yet, it inspires
amazement and wonder in close to two million
visitors a year.

A series of huge, eroded amphitheaters drained
by the Paria River, the park is filled with an intricate
maze of uniquely shaped pinnacles, hoodoos, arches,
windows, and castellated cliffs. Iron, manganese,
and other minerals have infused this fantasy world's

sandstone towers with an astounding spectrum
of colors, tinting them yellow, orange, lavender,
white, and pink. With warm days and sub-freezing
temperatures at night, Bryce experiences 200 freeze-
thaw cycles per year, making temperature one of the
most significant erosional forces at work.

The geological history of Bryce began 50 to 60
million years ago, when a series of huge freshwater
lakes occupied what would become the Colorado
Plateau. A thick deposit of sediment accumulated,
which would eventually be compressed into a layer
named the Clarion Formation, also now known as the
Pink Cliffs. 10 to 15 million years ago those lakebeds
were uplifted and splintered into several giant
plateaus: the Aquarius, at 11,000 feet the highest
plateau in America; the Markagunt, home of Cedar
Breaks National Monument; and the 9,000 foot
Paunsaugunt home of Bryce. Cut into the soft Clarion
Formation, Bryce Canyon is geologically one of the
youngest formations of the Grand Staircase. SEE ALSO
PAGES 4–5, 14, AND 276–277.

PAGE 89: **Bristlecone Pine, near Rainbow Point,** Bryce Canyon National Park, Utah.

In 1957 a University of Arizona scientist named Edmund Schulman, while doing research on climate, discovered a grove of ancient gnarled trees in the White Mountains of the Sierra Nevada in California. In that grove a particularly large and venerable specimen was dated, and discovered to be a remarkable 4,723 years old, making it one of the oldest living organisms on earth. Then in 1958 *National Geographic* magazine published a story covering Schulman's work and for the first time, the remarkable age of these trees and their ability to survive the harshest conditions was brought to worldwide attention.

Bristlecones thrive on desolate mountaintops and in the most extreme environments of wind blasted nutrient poor cliff edges. They often grow on grave of limestone or on steep dolomite slopes, near the tree line where survival is most difficult. They live in an ultra dry and cold environment and have little or no competition for the limited resources o their severe habitat. Growing season is a short six weeks. Brutal weather conditions include frequent snowstorms, deep winter drifts and searing summe heat, conditions that actually prolongs their longev They are impervious to insects, fungus, and bacteri infection.

Sculpted by the ravages of time, they have the appearance of driftwood that has been bleached metallic silver. The dwarf high altitude trees are composed of branches and trunks that have been carved and twisted by the wind. Often we observe a tree whose life hangs by a thread, a single thin strip o Xylem and bark supplying nutrients to a single branc A piece of Bristlecone pine wood found lying on the ground, has been dated by dendrochronologists to be over 9000 years old.

The average specimen lives 300 to 500 years. Be

ce Canyon and Cedar Breaks contain trees that
at least 1,500 years old. SEE ALSO PAGE 145.

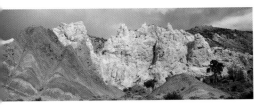

ES 104–105: **The Cockscomb, Cottonwood
nyon,** Grand Staircase-Escalante National
nument, Utah.

southern Utah, along the geologic divide between
Grand Staircase and the Kaiparowits Plateau,
crust of the earth has become compressed and
ctacularly folded; a section of this crust has been
ed on edge and eroded into a long series of sharp,
rated ridges. Twin lines of these jagged, triangular
s slice dramatically across more than 100 miles of
ah landscape.

Known to geologists as the East Kaibab Monocline,
s more commonly referred to as the Cockscomb,

for its resemblance in color and shape to a rooster's
headdress. This long series of precipitous cliffs,
oriented north-south, is striated with deep red
Entrada sandstone, alternating with tan, yellow, and
grayish-white layers of Navajo sandstone.

At the base of the formation is a seasonal stream
named Cottonwood Creek. Watering groves of giant
cottonwoods, pine and juniper, it is slowly eroding
its own winding canyon through the Cockscomb. SEE
ALSO PAGE 12.

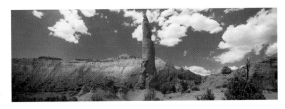

PAGE 111: **Ballerina Spire,** Kodachrome Basin State
Park, Utah.

Among the well-known national parks of Southern
Utah is a hidden gem, the diminutive 2,240-acre
Kodachrome Basin, a magical and unique landscape

255

of extraordinary beauty. Designated a state park in 1962, it protects 67 exceedingly rare geologic formations called sand pipes. Said to occur nowhere else on earth, these slender chimneys of sedimentary rock range from six feet to 170 feet in height, with diameters of up to 50 feet. Although the origin of these amazing structures is not fully understood, it is most likely that they are the petrified remnants of giant geysers and hot springs created when this region was geothermically active, as Yellowstone is today. The cylindrical vents and subterranean tubes of these features became filled with liquefied sand during repeated seismic activity. Over millions of years and under great pressure, this mixture of calcite, quartz, feldspar, and clay solidified into towering spires that seem to grow from the valley floor. It took additional eons of weathering for the softer surrounding Entrada sandstone to be worn away, exposing the exotic, slender forms we see today.

Around 1900, the region was called Thorley's Pasture, for a rancher who used it for winter grazing of cattle. Stories came out that it was an odd and spectacular place with unusually colored and shaped rock formations. So, in 1948, *National Geographic* mounted an expedition into this uncharted region, and in September 1949, published a magazine story that brought world attention to its strange beauty. The expedition's photographers used the relatively new Kodachrome transparency film to accurately capture the vivid colors of the cliffs and basin, hence its new name.

Almost completely surrounded by the huge Grand Staircase-Escalante National Monument, the basin's elevation, at 5,800 feet, receives enough moisture to sustain a semi-desert of pinyon pine and Utah juniper, with extensive stands of big sage, yucca, prickly pear cactus, native grasses, and seasonal blooms of wildflowers. In some areas thick layers of cryptobiotic soil are present, evidence of an undisturbed ecosystem.

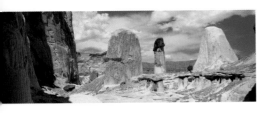

GES 114–115: **Hoodoos, Wahweap Creek,**
and Staircase-Escalante National Monument, Utah.

...is area, a series of plateaus that forms a gigantic
...ircase-like structure rising more than 7,000
...t, was first explored by Almon Thompson of the
...nn Wesley Powell mapping expedition in 1872.
...scribed by Powell as the "last blank on the map,"
...e Escalante was the last river to be mapped in the
...ver 48 states. The remote town of Boulder, Utah,
...s the last town in the United States to receive its
...il by mule, and didn't have electricity until 1948.
...The exquisite flowstone formations of Wahweap
...reek are some of the most unusual in the world.
...otected by capstones of harder material, a
...ft, chalky white layer of stone has been eroded into
...nder, fluted spires. These remarkable sculptures

are so fragile that a careless misstep could destroy
what has taken millions of years to create.

The monument was created in 1996 and is one
of the few entire ecosystems to be preserved. At 1.9
million acres, it is one of the largest protected areas
in America. A battleground for conservationists and
developers, it has survived the uranium boom of the
1950s and a proposed coalmine and power plant of
the early 70s. Crossed by only one paved road, Grand
Staircase remains remote, isolated, and majestic.
SEE ALSO PAGES 8–9.

PAGE 134: **Long Canyon,** Grand Staircase-Escalante
National Monument, Utah.

East of the Kaiparowits Plateau, the Escalante River
has carved one of the most stupendous and complex

257

canyon systems on the planet. Among the myriad tributaries of this remote river is Long Canyon, which drains the western part of Circle Cliffs Basin.

Long Canyon is deep and narrow, with sheer walls of Wingate sandstone. At the base of these cliffs are alcoves sheltering small gardens of pinyon and juniper. On the floor of the canyon, gigantic sandstone blocks, which have fallen from the cliffs above, form a chaotic scene of fractured boulders and scree slopes. Apparently untouched for tens of thousands of years, strange pinnacles, eroded incredibly thin and delicate, are surrounded by lavender-tinted mud and yellow shards of rock.

The Burr Trail, which cuts across the Circle Cliffs Basin, was originally built in the 1880s by John Atlantic Burr to move cattle between their winter and summer ranges on the Aquarius Plateau and the Colorado River. It was not until 1950 that a good road was made into Long Canyon. The Burr Trail Road, now designated a "National Scenic Backway," begins on the Aquarius Plateau, goes through Grand Staircase-Escalante National Monument and Capitol Reef National Park, and ends in Glen Canyon National Recreation Area.

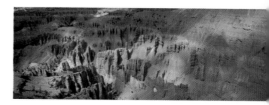

PAGES 138–139: **Jericho Canyon from Point Supreme,** Cedar Breaks National Monument, Utah

Geologically related to Bryce Canyon, their neighbor 35 miles to the east, the "breaks" are a series of broad amphitheaters deeply eroded into the western rim of the Markagunt Plateau and filled with vividly colored and uniquely shaped rock formations. Three miles wide and over 2,000 feet deep, it is part of the Grand Staircase, a succession of giant escarpments, or steps, made of sedimentary rock, which exposes 200 million years of the earth's geological history. In 1933 President Franklin Roosevelt made Cedar Breaks into a national monument.

Copious amounts of rain and heavy spring runoff have made this one of the most rapidly eroding places in America. In fact, it was called *U-map-wich,*

the "place where rocks are sliding down all the [ti]me," by the indigenous Southern Paiute. This rapid [ra]te of differential erosion has cut deeply into the [co]lored cliffs of the Clarion Formation, creating [ba]dlands populated with an amazing array of slender [spi]res, columns, pinnacles, and arches. Minerals such [as] calcium carbonate, iron oxide, and manganese [ha]ve resulted in cliffs, canyons, and hoodoos dyed, [ac]cording to color analysts, with 50 different hues of [re]d, yellow, and purple.

At more than 10,300 feet in elevation, Cedar [Br]eaks experiences severe winter storms and almost [arc]tic extremes of temperature. For seven months [of] the year, it is blanketed by snowdrifts of 15 feet [or] more and blasted by frigid gale-force winds. The [an]cient bristlecone pines—like those in neighboring [Br]yce Canyon—cling tenaciously to barren cliffs. [D]uring the relatively brief spring and summer [se]asons, the forests are interspersed with flower-filled [me]adows, and the air is scented with the fragrance of [su]b-alpine fir and Engelmann spruce.

Cedar Breaks' remote location and severe weather [ha]s limited human visitation throughout its history.

The inaccessibility of the deep inner gorges has prevented grazing and other disturbances by man, leaving a rich and relatively pristine ecosystem undisturbed.

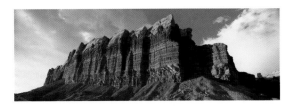

PAGES 148–149: **The Egyptian Temple,** Capitol Reef National Park, Utah.

The name of this national park refers to the term "reef" or barrier, and the resemblance of the white Navajo sandstone domes to the Capitol Building in Washington, D.C.

This assemblage of towering monoliths, narrow canyons, multicolored ash fields, and vast deserts was, until recently, relatively unknown. Pioneers named the formations, which could only be crossed in a few places for more than 100 miles, Waterpocket Fold

and the Great Escarpment. First designated as a national monument in 1937, the area became Capitol Reef National Park in 1971, and now protects more than 250,000 acres.

The Egyptian Temple, shown here, resembles the prow of a ship as it juts out of the Great Escarpment. A hard cap of yellowish Shinarump sandstone protects the softer red Moenkopi sandstone from erosion. SEE ALSO PAGES 6–7.

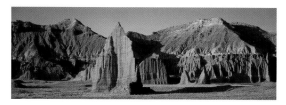

PAGES 152–153: **Temple of the Moon, Lower Cathedral Valley,** Capitol Reef National Park, Utah.

I have visited Cathedral Valley twice and now understand what Ward Roylance was referring to when he wrote, "Cathedral Valley has captured us, body and soul. How can we explain the mystic lure of that place?

To us it represents the purity of earth, sky, and form. Its shapes and designs are cosmic archetypes, deeply meaningful to those with mystical leanings."

On both visits, Martha and I left the sleepy town Torrey at 4 A.M., driving a long dirt road to greet the dawn at the base of two pyramid-shaped monoliths. Appropriately named the Temple of the Sun and the Temple of the Moon, they are spectacular isolated peaks with sharply tapered and fluted ramparts. One cannot stand in front of them without being filled with awe and wonder at the way they rise steeply 200 to 300 feet above the flat desert floor. At the moment of sunrise they first glow pink and then an unearthly fiery orange. Upper Cathedral Valley is similarly graced with solitary monoliths, and rimmed with immense sheer cliffs pleated with curtain-like striations.

These exotic erosional remnants received their names in 1945 from Frank Beckwith and Charles Kelly, the latter being the first superintendent of Capitol Reef. Calling to mind religious structures such as temples and Gothic cathedrals, the two men felt that the extraordinary beauty of this place was of a spiritual nature.

It wasn't until 1960 that this huge area was ded to the Capitol Reef National Monument to entually become part of the national park. Still mote, imposing, and surprisingly fragile, Cathedral lley continues to evoke powerful feelings in all no experience it, for it is truly as Ward Roylance scribed: "the Enchanted Wilderness."

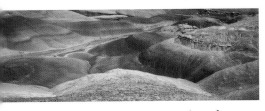

GES 160–161: **Bentonite Hills,** Capitol Reef ational Park, Utah.

ne hundred forty million years ago, during the rassic period, sediments from vast swamps and kes were laid down in thick deposits. These were mpressed into soft layers and, eventually, eroded to the rounded, hill-like mounds resembling a oonscape of colored clay found in this area of Utah.

Discovered in 1898 by W. C. Knight—who found large deposits of this material in Fort Benton, Wyoming—the Bentonite Hills are technically described as a "Bushy Basin shale member." Actually a combination of silt, fine sand, and volcanic ash, the hills are barren and almost completely devoid of vegetation, as the fine clay and minute glass particles of the ash are inhospitable to plants, lichens, and even hardy cactus. Several large areas in and around Capitol Reef National Park are dubbed the "Rainbow Hills," for their banded patterns and many hues. Minerals such as aluminum have created layers with various shades of brown, deep red, purple, and greenish gray. After rains, as drying occurs, the surface takes on a crumbly, popcorn-like appearance.

Bentonite has proved to be a valuable resource, its layers of clay and volcanic glass particles giving it some unusual physical properties. It can absorb seven to 10 times its own weight in water, swelling to 18 times its dry volume. Extraordinarily sticky and slippery when wet, bentonite clay is very difficult to walk through unless it is completely dry. Indians used it for soap, and early pioneers used it as a lubricant for wagon wheels

and as a roofing sealant in log cabins.

Today bentonite has important industrial uses in the manufacture of detergents, pharmaceuticals, agricultural products, and in construction. It is exploited through quarrying and processed into pellets and powders.

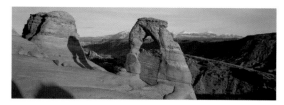

PAGES 164–165: **Delicate Arch,** Arches National Park, Utah.

Poised precariously on the rim of a huge sandstone basin, framing the snow-clad peaks of the La Sal Mountains with its thin curve of stone, Delicate Arch is the embodiment of Utah's high desert. Because of its unique and graceful shape, it has become a holy grail for hikers and photographers alike.

For Delicate Arch to be formed, a series of rare and convergent circumstances had to occur: More than 100 million years of deposition, uplift, and erosion produced a freestanding fin of red Entrada sandstone. Eventually, the weathering action of countless freeze-and-thaw cycles wore the fin thin enough in one place to make a small opening. Continued wind and rain have enlarged it to its present extraordinarily fragile and fantastic form. A capstone of harder material protects the 45-foot opening, causing the differential weathering that ultimately creates arches and windows.

Now an icon of the West, its likeness is reproduced on everything from the Utah license plate to countless key chains, place mats, and postcards. But nothing can prepare us for the sight of the actual formation. Reached after a short but steep hike of one and a half miles, the final approach is along a narrow ledge of stone. And then, around an abrupt corner, Delicate Arch suddenly comes into view. Only when we get closer and finally underneath it does the great size, phenomenal beauty, and, most important, sheer improbability of this natural stone sculpture sink in.

As the last crimson rays of the sun paint the delicate span, it begins to glow with a truly incandescent light.

too soon, the fiery radiance begins to fade, first
ing into a soft rosy pink, and then going steely
, as if someone had turned off a switch. As bats
wheel and somersault across the night sky, we
exalted to have experienced one of the countless
ders sequestered in Arches National Park.

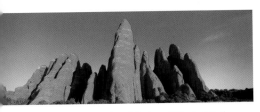

ES 170−171: **Fins,** Arches National Park, Utah.

re the slow but relentless erosion of Entrada
dstone has produced a dramatic landscape of
krock punctuated by towering spires, pinnacles,
s, balance rocks, and huge orange-colored cliffs.
aside as a national monument in 1929 and
graded to a national park in 1971, Arches protects
greatest collection of natural stone openings in
world. At just over 75,500 acres, it contains more

than 2,200 catalogued arches, windows, holes, and
other pierced formations, from the smallest opening,
at three feet wide, to Landscape Arch, which is, at
306 feet from base to base, the longest stone span
on earth.

With elevations ranging from 3,960 feet to
5,653 feet above sea level, Arches is baked with
summer temperatures reaching 110 degrees and
frozen by near-zero temperatures in winter, its
physical environment a reflection of those extremes.
More than one third of Arches is bare slickrock,
interspersed with miniature gardens of pinyon pine,
gnarled junipers, lichen, and cactus. Its key ecological
component however, is *cryptobiotic* soil, which covers
70 percent of the park. Named for the Greek
word for "hidden life" this "soil" is actually a thin,
living crust composed of bacteria, fungus, lichen,
and *cyanobacteria*, or blue-green algae. It has been
described as the topsoil of the desert, for its ability to
hold water and provide critical nutrients that sustain
the desert wilderness. Extraordinarily slow-growing
and fragile, this community of microscopic organisms
takes more than 250 years to repair the damage

of a mountain-bike track or a single set of careless footprints. Some areas of undisturbed "crypto" have grown more than six inches high and may be many thousands of years old.

In 1956 and 1957, when Arches was still just a national monument, a seasonal ranger named Edward Abbey kept a detailed journal of his experiences and observations there. Ten years later, he wrote the seminal book *Desert Solitaire, A Season in the Wilderness*. In it, he railed against the growth of industrial tourism and overdevelopment of our national parks. His was one of the most poetic and politically charged voices of the time on the protection of desert wilderness. And if anything, his words ring with greater truth today, and his message has become more critically important. In 1956, visitation in Arches was about 28,000. Currently, it is about to top one million visitors a year.

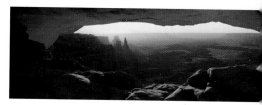

PAGES 180–181: **Mesa Arch,** Canyonlands National Park, Utah.

Canyonlands encompasses 337,570 acres of canyons, fins, arches, buttes, and needles, as well as vast grassland basins and forests of Utah juniper and pinyon pine. A large Clovis projectile point found here established that this area was inhabited by nomadic Paleo-Indians at least 11,000 years ago.

The first white people to see the area were members of the 1859 Macomb Expedition. Then the U.S. Army Corps of Topographic Engineers explored the course of the San Juan and Colorado rivers, and published an important map covering this region in 1860. In 1869 and 1871, John Wesley Powell and his group floated down the Green and Colorado, the two great rivers that cut through the incredibly complex landscape th

ad out before them. Powell carefully selected a
ntific team to report on the geology, plants, animals,
the extensive Indian ruins they discovered. They
e the first to describe the geological wonders that
ld become Canyonlands National Park about 100
rs later, in 1964.

Ranging in elevation from 3,720 feet to 6,987 feet,
area's convoluted topography was so impenetrable
t it was first thought impossible to explore on foot,
lanes were used to fix routes into the labyrinth
arrow valleys and serpentine canyons. Today
nyonlands remains one of the most rugged and
ote wilderness areas in America.

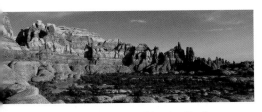

ES 182–183: **Needles, near Chesler Park,**
nyonlands National Park, Utah.

One of the most striking landscapes in the West
is the distinctive Needles District in Canyonlands
National Park. Located just east of the confluence of
the Colorado and Green rivers, sheer walls of stone
have been eroded into long rows of slender, sculpted
pinnacles. Horizontally striped with pink and white
layers of Cedar Mesa sandstone, some reach over 800
feet into the sky.

Fins, buttes, and towers punctuate this vast area
of high desert and huge cliffs split by deep fissures.
Serpentine canyons have cut deeply through massive
layers of slickrock. Twisted specimens of pinyon pine
and Utah juniper, some more than 700 years old,
shade ancient gardens of fragile cryptobiotic soil
and cactus. Hidden among towering rock faces and
surrounded by fortifications of spires are great open
expanses geologists call *parks*. Actually desert prairies,
they host rare native grasses and spectacular blooms of
spring wildflowers.

Although ranchers used the area in the 1870s, most
of the region was so rugged and inaccessible that it
has remained relatively unspoiled. The search for
uranium caused a rush of development with roads and

dirt airstrips carved into the wilderness, but the boom ended in the early 1950s and Canyonlands once again became a place of stunning silence and far horizons. Bates Wilson, superintendent of Arches National Monument in the 1950s, began explorations of the Canyonlands area, and soon realized the importance of protecting what would become, in 1964, Utah's largest national park.

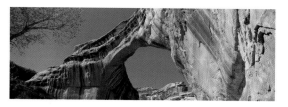

PAGE 189: **Sipapu Natural Bridge,** Natural Bridges National Monument, Utah.

In 1883, a prospector by the name of Cass Hite was working at a placer-mine camp on the Colorado River. Led by a Piute guide, he hiked up nearby White Canyon in search of gold. Instead he found an astounding sight: Three enormous natural stone bridges arched across the great depths of the canyo Made of ancient light-colored sandstone, they emanated a powerful aura of spirituality. In fact, th three stone spans are among the largest in the wor and had been worshiped by the Paleo-Indians and their descendents, the Hopi, for thousands of year

The largest and most magnificent of the three, with an impressive span of 268 feet and a height o 220 feet, was named *Sipapu*, or "place of emergenc Considered a sacred portal to the underworld, it is also the second-largest natural bridge in America.

Bridges differ from arches in the mechanism of their origin. Bridges are created by the erosion of rock by moving water, such as streams or rivers, wh arches are formed by fracturing and weathering. At a time when this area's climate was cooler and wetter than it is now, gravel-laden steams and flash floods sculpted these bridges. Kachina is considere the youngest, Sipapu middle-aged, and the oldest, Owachomo. At 106 feet high, its fragile 180-foot s has been worn down to a thickness of only nine fee

Much more rare than arches, these three formations comprise the greatest concentration of

at bridges found anywhere. In 1908 more than
00 acres of upper White Canyon were preserved
Theodore Roosevelt, creating the Natural Bridges
ional Monument.

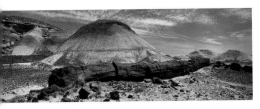

ES 202–203: **Puerco Ridge,** Petrified Forest
ional Park, Arizona.

ong the windblown badlands of a desolate region
northern Arizona is the largest and most colorful
ncentration of fossilized trees in the world. In the
l 1800s, U.S. Army surveyors first described it as
igh desert plain with distinctive domes made of
ored sandstone and volcanic ash, a strange place
ere "a painted desert was littered with gigantic
es turned to stone."
Here a complex sequence of specialized conditions
has allowed fossilization to occur in especially fine
detail and in a remarkable range of brilliant and
iridescent colors. Two hundred and twenty five
million years ago, thousands of gigantic conifer trees
were uprooted and washed into a floodplain. Covered
with thick deposits of silt, mud, and volcanic ash,
the logs were cut off from oxygen, greatly slowing
the natural process of decay. Silica-laden water
seeped through the logs, and over countless eons,
replaced the original plant tissue, cell by cell. Stained
by mineral inclusions such as iron, manganese,
cobalt, and chromium, Petrified Forest displays a
kaleidoscopic array of colors, with trunks appearing
like translucent crystals on a grand scale.

Protected as a national monument in 1909 by
Theodore Roosevelt, Petrified Forest was upgraded
to national park status in 1962 and enlarged in 1970
with the addition of the 50,000-acre Painted Desert
Wilderness Area.

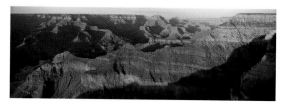

PAGE 207: **Mather Point, South Rim,** Grand Canyon National Park, Arizona.

Clearly visible from space, 277-mile-long Grand Canyon is the greatest canyon on earth. In this abyss, more than a mile deep, scientists have identified 23 layers of sedimentary and metamorphic rock, creating an unbroken geological record that covers two billon years of the earth's history.

First visited by Native-American hunters and later by prospectors and ranchers, its hidden mazes of side canyons and vast panoramas of unimaginable beauty remain a true wilderness. The canyon was virtually unexplored until John Wesley Powell made his historic expedition down the rapids of the Green and Colorado Rivers in 1869. He wrote, "The stupendous cliffs by which the plateaus are bounded are of indescribable grandeur and beauty."

Covering more than 1 million acres, the Grand Canyon has been viewed by many, but few have co to experience its grandeur and solitude intimately. fully explore its myriad secret places would require more than a lifetime. Clarence Dutton described t canyon in 1882 as "transcending the powers of the intelligence to comprehend it."

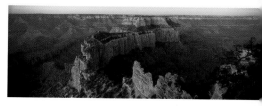

PAGES 208–209: **Cape Royal, North Rim,** Grand Canyon National Park, Arizona.

The north rim of the Grand Canyon, although separated from the south rim by an average of only miles, is in fact a world away. Completely cut off by deep winter snow from mid-October through mid-April, it becomes a preserve where plants and anim

protected and free of any human interference. The crown jewel of the north rim, and Grand Canyon's most spectacular viewpoint of all, is the aptly named Cape Royal, the southernmost tip of the Walhalla Plateau. Jutting out into the canyon's depths at 7,865 feet above sea level, it is a sub-alpine paradise, a unique wilderness surrounded by precipitous cliffs. Clothed with an ancient forest of ponderosa pine, spruce, aspen, and Douglas fir, it is home to such rare and endemic species as the tassel-eared Kaibab squirrel and the Grand Canyon swallowtail butterfly, *Papilio indra kaibabensis*.

It was about 3 A.M. when the alarm sounded, and we were out of the cabin by 4. Carefully driving the narrow winding road in pitch black, we finally arrived at the trailhead for Cape Royal. The stars were still visible and there was a distinct chill in the spring air. As soon as I stepped outside, I was surrounded by the most intense and overpowering fragrance I have ever encountered. Hundreds of thousands of ancient cliffrose trees were in bloom simultaneously. The air was so thick with the sweet scent of their blossoms that it practically made us dizzy. The creamy-yellow blooms, like miniature roses, produce a powerful orchid-like scent with a hint of vanilla, lemon, and jasmine, as beautiful and dense as any perfume.

We arrived at the viewpoint as the sky began to lighten. The harsh sound of a raven echoed out of a side canyon as the breathtaking panorama unfolded. The shadowed depths remained hidden. Gradually the canyon became alive, illuminated with soft pink light as the sun rose over a vast and ancient landscape of towering cliffs.

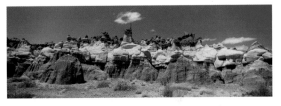

PAGES 218–219: **Moenkopi Wash,** Hopi Indian Reservation, Arizona.

The Ancestral Puebloan culture flourished from about A.D. 800 to 1300. During that time they built the most advanced and complex structures in the prehistory

of North America. Their highly developed art and architecture is evidence of their successful interface with an extreme and unforgiving environment.

It is generally accepted that the descendents of the Ancestral Puebloans are the present-day Hopi. They are considered the most unchanged, as far as spiritual traditions, of any of the native tribes in North America. Called the *Hisatsinom*, or the "ancestors," they continue to cling to an ancient and sacred way of life, developed during 1,500 years of desert occupation.

Three canyons of the Hopi Nation are found along the western edge of Moenkopi Plateau, an extension of the much larger Black Mesa to its north. Moenkopi Wash, the northernmost stream, is more than 90 miles long. Called *Naak a kee dílyehe*, or "where cotton is cultivated," this canyon is one of the few to have a permanently running stream, and once supported extensive cultivation of traditional crops, such as cotton, corn, and beans. First described by Europeans in 1823—by members of the Vizcarra expedition—the stream headwaters on the southwestern slopes of Black Mesa and exits through Blue Canyon to become one of the main tributaries of the Little Colorado.

Honooji, or "saw-toothed," Canyon is filled with jagged, horizontally banded towers. Eroded more than 1,000 feet deep into the Mesa Verde and Mancos shale, the towers are striped with red, purp gray, and a distinct black layer of coal. These coal seams were laid down by the accumulation of dead vegetation more than 100 million years ago. Sparke by lightning, the seams caught fire and oxidized the layers of stone above them. Indian medicine men have used the reddish oxidized layers and othe fine-grained colored sands of Honooji Canyon for centuries.

Ha ho no geh, or "too many washes," Canyon was also called *Hasí nagí*, or "enormous in size." One of t tributaries of Moenkopi Wash, it is characterized by spectacularly long and steep escarpments. Countles sub-canyons radiate in all directions and are also of immense size. Each is ringed by fortifications of delicately carved and fluted cliff walls composed of cream, gray, and yellowish flowstone. One of the mo remote canyon systems in the West, it is not well explored and little has been written about it.

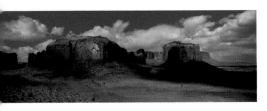

PAGE 227: **Mitchell Mesa, Elephant Butte, Cly Butte,** Monument Valley Navajo Tribal Park, Arizona.

A truly a timeless land, Monument Valley was first inhabited by Ice-age Paleo-Indians between 12,000 and 6,000 B.C. Later, the Kayenta Anasazi hunted and gathered wild food there, from the first century to about A.D. 1300. And in historic times the Navajo have continued to practice their ancient traditions of sheep herding and limited agriculture throughout this region.

Situated on the Arizona-Utah border, Monument Valley is a fantastic collection of buttes, mesas, and delicate spires, some of which rise over 1,000 feet from the desert plain. In 1958, about 30,000 acres were designated as the Monument Valley Navajo Tribal Park. Now expanded to 91,696 acres, it includes vast stretches of high desert punctuated by vivid crimson pinnacles, massive buttes, and wind blown dunes of orange sand.

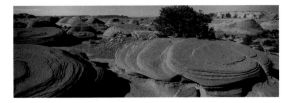

PAGE 229: **Mystery Valley,** Monument Valley Navajo Tribal Park, Arizona.

Their creators first gave the Navajo the name *Nihookaa Diyan Dine*. It is translated to mean "Holy Earth People" or "Lords of the Earth." Today they call themselves simply the *Dine*, or "the people."

According to their creation story, there were three previous underworlds. The *Dine* emerged from the underworld into this world—the fourth, or "Glittering World," by climbing through a magic reed. The deities then created the Navajo homeland by placing four holy mountains in the four directions, as the

boundaries of *Deneteh*, their sacred world. Then they placed the sun, the moon, and the stars in the sky, and finally created the other necessities of life, the clouds, the trees, and rain.

The *Díne* revere any manifestation of Mother Earth or Father Sky, and Monument Valley, known as *Tse bii ndzisgaii*, or "the valley within the rocks," has always been a sacred place to them. Mystery Valley and Hunts Mesa look out upon exotic landforms that, to the *Díne*, symbolize a time when deities inhabited this place. As vast and as overpowering as Monument Valley is, it is but a tiny portion of the 16-million-acre Navajo Nation.

On my visit to Mystery Valley, I was accompanied by Wilson, a Navajo guide from the Kayenta area. The entire time we were there, he showed extreme reverence for the sacredness of the place. He kept a low voice, and while I explored and photographed, he carefully collected several different species of plants that would be used later during traditional ceremonies.

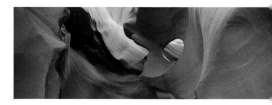

PAGES 236–237: **Antelope Canyon Navajo Tribal Park,** Arizona.

Slot canyons are some of the most unusual and beautiful geological formations in the world. The largest concentration of these occurs in the Colorado Plateau of the American Southwest. The slot canyons of this region contain the most vividly colored and shaped rocks found anywhere. Formed by the erosive force of water cutting through the richly colored layers of Navajo and Kayenta sandstone, each slot canyon is as unique as a snowflake, and each is a spectacular visual experience, a surreal world of seemingly infinite swirling forms and sinuous passageways.

Repeated cataclysmic floods, caused by monsoon storms that sweep across the Colorado Plateau in the late summer, are responsible. Water roars through

ese canyons with an almost unimaginable force,
rging 50 feet high and carrying car-size boulders.
hese floods scour everything in their path.

Many of the most beautiful slot canyons are
n Navajo land, and many others are found in
on, Bryce, Grand Staircase-Escalante National
onument, and Paria Canyon-Vermilion Cliffs
ilderness. No one actually knows how many there
e, and new slots are being discovered every year.

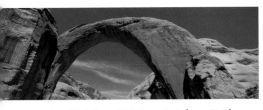

tuated in a remote wilderness, Rainbow Bridge is
e largest natural stone bridge in the world. This
mense, perfectly balanced, symmetrical rock span,
5 feet wide and 291 feet high, was worshipped

for thousands of years by the Kayenta Anasazi. A
prominent feature of numerous Navajo creation
stories, the bridge is hidden among a labyrinth of
unexplored slot canyons that radiate from the base of
Navajo Mountain, an important symbol of the *Dine*
sacred world.

The first white man to see the bridge was Byron
Cummings, who was led there by a Navajo guide,
Nasja Begay, in 1910. In 1910, Rainbow Bridge
became a national monument of a mere 160 acres,
protected by President Taft.

This natural wonder weathered millions of years
of frost, snow, rain, and blistering heat, yet was nearly
destroyed in the 1960s by the rising waters of Lake
Powell when Glen Canyon was flooded.

The perfectly proportioned ramparts of Navajo
sandstone glow radiantly at sunrise and sunset.
Beautiful from any angle, the bridge continues to
astound all who are fortunate enough to witness its
grandeur and majesty. As Clyde Kluckhohn wrote in
his book *Beyond the Rainbow*, the bridge "awes one into
silence. . .One stands as in a temple."
SEE ALSO PAGES 16–18.

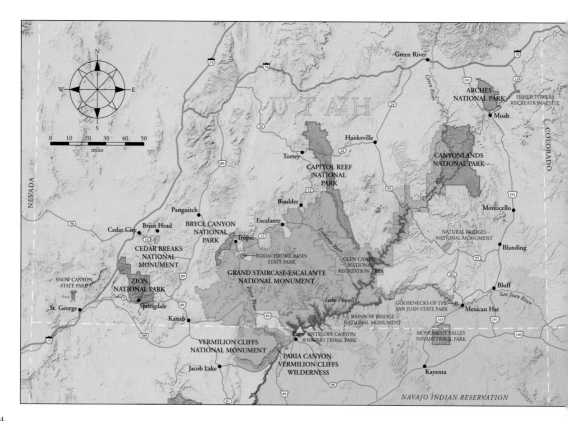

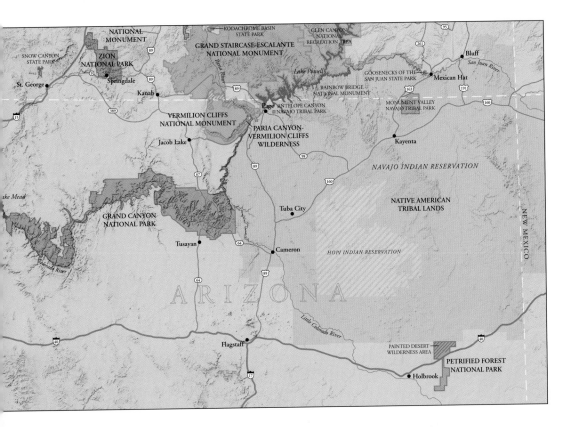

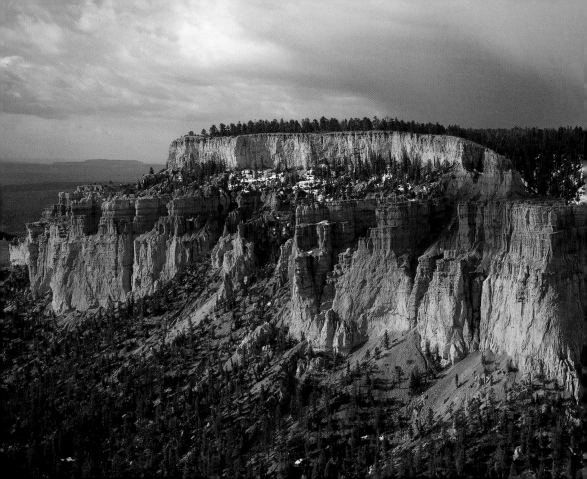

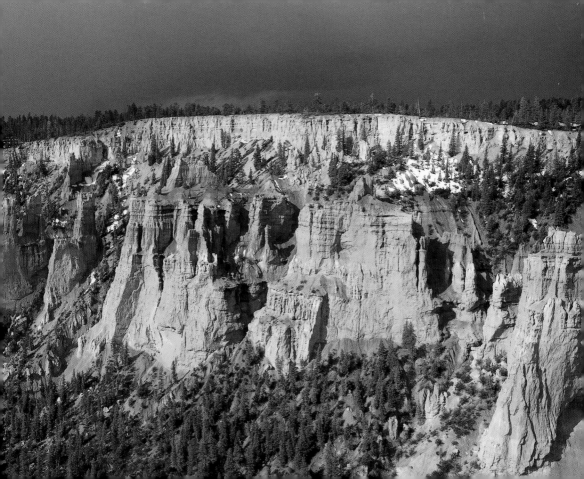

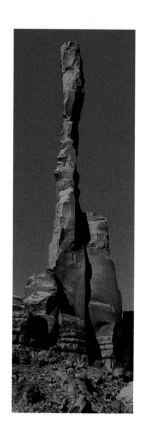

ACKNOWLEDGMENTS

MARTHA MCGUIRE walked along side me every step of way on each winding trail. She been unfailingly dedi to our relationship, our business and all of the projects w have undertaken. She is the key ingredient to the succes of all the adventures we experience. We share our lives i unique and wonderful way and I cherish each day that w spend together.

LENA TABORI's vast experience in the publishing world i matched by her literary insight and intellect that gives he special understanding of what makes compelling books. S has fostered countless careers and validated many artists' important work. She leads with grace and a rare combina of encouragement, joy, and perhaps most important, love

GREGORY WAKABAYASHI brings creativity and sophistica to every project. His superb sense of design creates a synt of photography and the art of fine bookmaking. His asto ing memory for images allows him to absorb a huge body work and unerringly choose the most important element feature. He honors each project through his deep unders ing, and adds his inimitable design contribution by clarify

nd distilling the photographs as well as the ideas and
etics they illustrate. He pursues excellence and perfec-
without fail. I could not ask for a more sympathetic and
iderate collaborator. Every chance to work with Greg is a
, experience, one I hope to repeat many times.

ect director, ALICE WONG, holds the physical aspects of
ook together with her patient and erudite assessments.
leads the entire production team, interfacing with
ers, printers, designers, editors, and artists. Her wisdom
experience provides answers to a never-ending series
itical decisions that must be made quickly. She is the
all editor of text and makes the most complicated issues
simple and enjoyable. She devotes meticulous atten-
to every detail, working with unfailing care and respect
each project. It is a joy to work with her on every book.

y thanks to the rest of the Welcome team for their
cation and hard work throughout the project. The
e Welcome family creates an atmosphere of love and
ort that is rare and beautiful.

he canyons and deserts of the West we were helped
ind and knowledgeable people who also became good
ds. I would like to thank:

KATE SEASE for her strength, vast knowledge, and love of
wilderness and her hard work and good cheer in the Paria
Narrows, Coyote Buttes South, and White Pocket.

HAROLD SIMPSON of Monument Valley for his friendship,
kindness, and the beautiful sound of his Navajo flute.

KATHY and ROLAND MUNZEN of Page, Arizona, for their
friendship and generosity.

ELISE ROBINSON, from US Airways Group, Inc., for her
kind assistance with flights and for facilitating the transport
of heavy film and equipment.

We would like to thank VIRGINIA ROYLANCE, of Salt Lake
City, Utah for her kind permission to reproduce poetry and
other quotes from Ward J. Roylance's book, *The Enchanted
Wilderness*.

—JON ORTNER

PAGES 276–277: **Pink Cliffs,** Bryce Canyon National Park, Utah.

OPPOSITE: **The Totem Pole,** Monument Valley Navajo Tribal Park,
Arizona.

PAGE 1: **The Wave,** Paria Canyon-Vermilion Cliffs Wilderness, Arizona.
PAGES 2–3: **White Pocket,** Vermilion Cliffs National Monument, Arizona.
PAGES 4–5: **Bryce Amphitheater from Sunset Point,** Bryce Canyon National Park, Utah.
PAGES 6–7: **Waterpocket Fold,** Capitol Reef National Park, Utah.
PAGES 8–9: **Wahweap Creek,** Grand Staircase-Escalante National Monument, Utah.
PAGES 10–11: **Yei Bi Chei and The Totem Pole,** Monument Valley Navajo Tribal Park, Arizona.
PAGE 12: **The Cockscomb, Cottonwood Canyon,** Grand Staircase-Escalante National Monument, Utah.
PAGE 13: **The Lollipop, White Pocket,** Vermilion Cliffs National Monument, Arizona.

Welcome Books®
An imprint of Rizzoli International Publications, Inc.
300 Park Avenue South
New York, NY 10010
www.rizzoliusa.com

Publisher: LENA TABORI
Project Director: ALICE WONG
Editorial Assistant: ROBYN CURTIS
Designer: GREGORY WAKABAYASHI

Library of Congress Cataloging-in-Publication Data on

ISBN: 978-1-59962-079-4

FIRST EDITION

10 9 8 7 6 5

Printed in China